How to Draw
DOGS&CATS
from Simple Templates

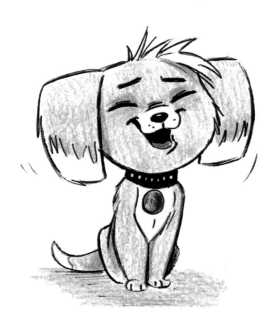

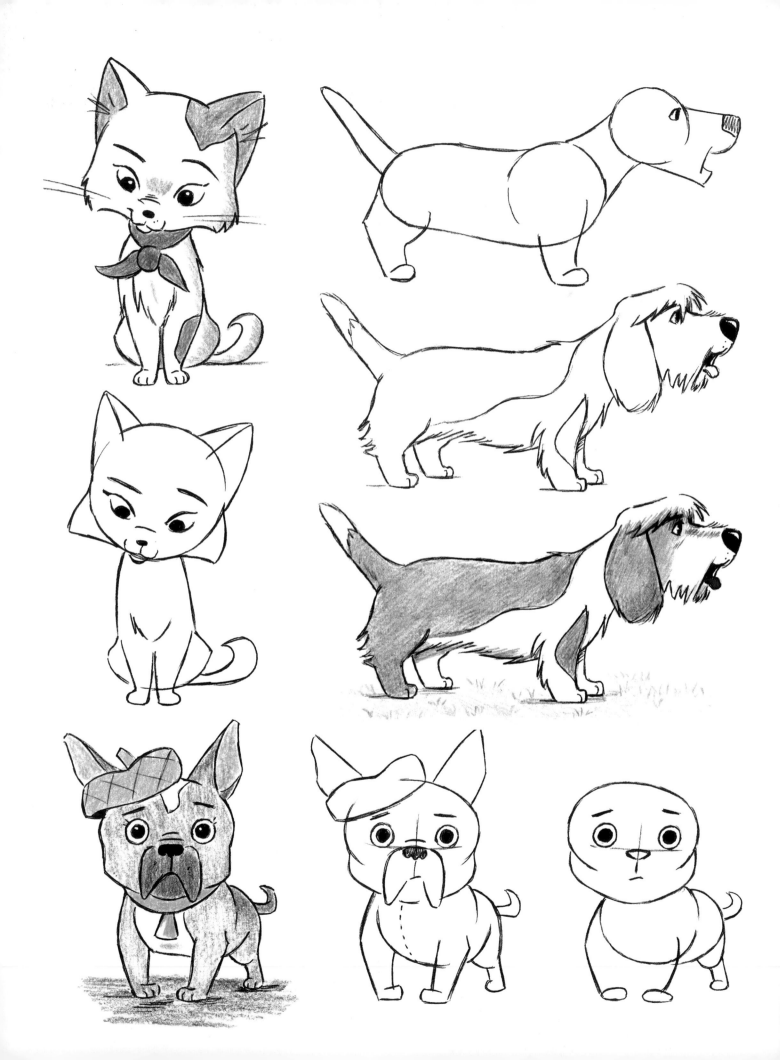

How to Draw
DOGS&CATS
from Simple Templates

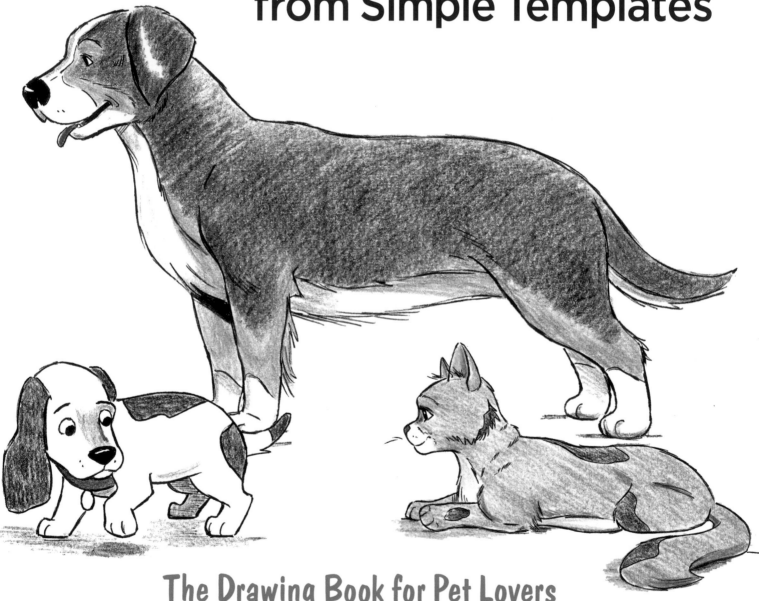

The Drawing Book for Pet Lovers

Get Creative 6

DRAWING WITH Christopher Hart

An imprint of **GET CREATIVE 6**
104 West 27th Street
Third Floor
New York, NY 10001
sixthandspringbooks.com

Managing Editor
LAURA COOKE

Senior Editor
MICHELLE BREDESON

Art Director
IRENE LEDWITH

Chief Executive Officer
CAROLINE KILMER

President
ART JOINNIDES

Chairman
JAY STEIN

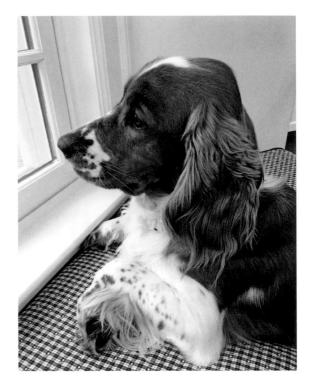

For my dog Spencer, who is keeping the world safe from squirrels.

Library of Congress Cataloging-in-Publication Data
 Hart, Christopher, 1957- author.
How to draw dogs and cats from simple templates : the drawing book for
 pet lovers / by Christopher Hart.
First edition. | New York : Drawing with Christopher Hart, LCCN 2018039437 | ISBN 9781640210318 (pbk.)
Dogs in art. | Puppies in art. | Cats in art. | Kittens in art. | Pencil drawing--Technique.
LCC NC783.8.D64 H375 2019 | DDC 743.6/97--dc23
LC record available at https://lccn.loc.gov/2018039437

Manufactured in China

3 5 7 9 10 8 6 4

First Edition

CONTENTS

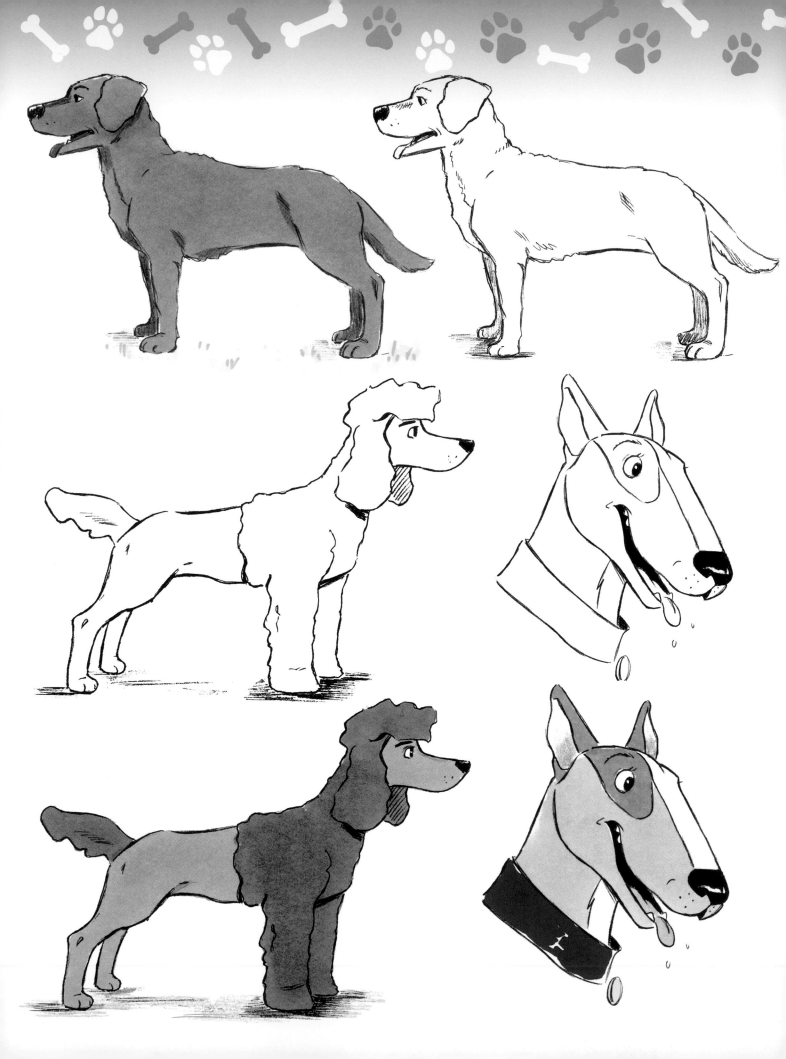

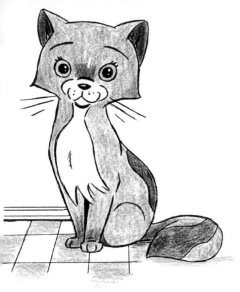

INTRODUCTION

There's nothing like a beloved pet to warm your home, brighten your day, and chew up your socks. Now you can have even more fun by learning to draw your favorite furry friend.

I'll show you how to draw the most popular pets—dogs and cats—with ease. I've broken down what could be complex drawings into the simplest shapes to create "templates"—basic forms that can be used as starting points to begin each drawing the right way.

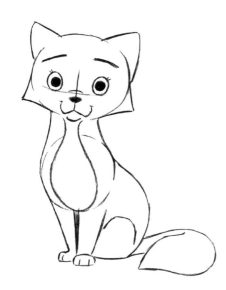

From those basic templates, a generous number of steps provide clear progress to complete dozens of finished drawings. Many detailed illustrations and "Pet Tricks," or tips, are sprinkled throughout the book to make the concepts even easier to grasp.

You'll find a great variety of dog and cat breeds to draw, along with their classic poses and expressions. Family favorites such as the loyal golden retriever, the high-energy Jack Russell terrier, and the portable miniature schnauzer all make appearances. We'll also cover mixed breeds, as well as intriguing rare breeds such as the visually striking saluki and the good-natured Cesky terrier.

Popular cat breeds are well represented, including the supremely fluffy Norwegian forest cat, the elegant Russian blue cat, the endearingly stubby-tailed American bobtail, and common mixed types.

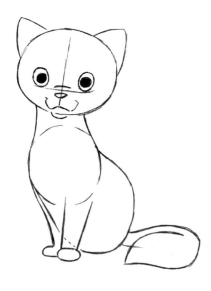

Like puppies and kittens? ("Who doesn't?" you ask.) There are two chapters devoted to drawing these lovable youngsters.

Dogs and cats make wonderful companions. Now you can learn how to draw them. And the best part? Drawings of pets won't play tug of war with your socks.

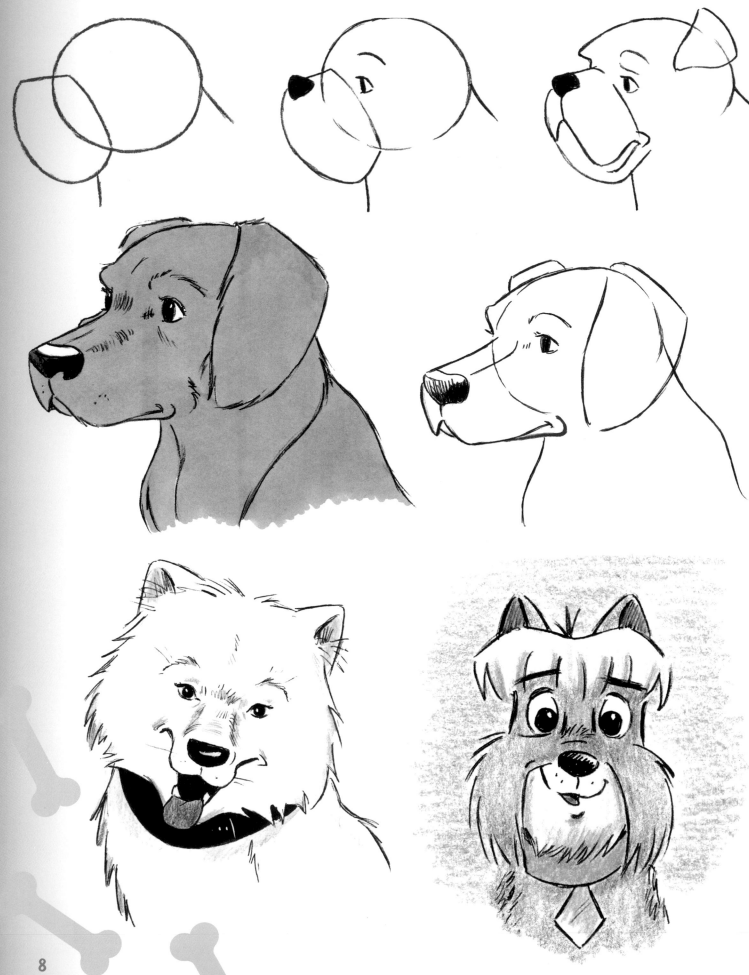

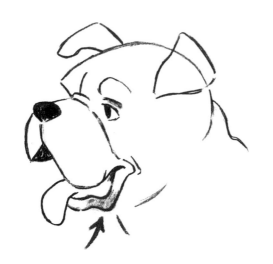

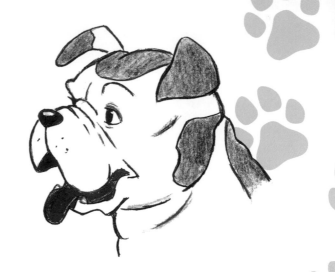

DRAWING DOGS
PET PORTRAITS

When you draw your dog's head, you create what's called a pet portrait. In this chapter, you'll learn to draw portraits of the most popular kinds of dogs as well as some rare breeds. I'll cover drawing the head from a variety of angles and with different expressions, poses, and markings. One word of advice: Try not to erase any of your dog drawings just below the chin. It makes them giggle.

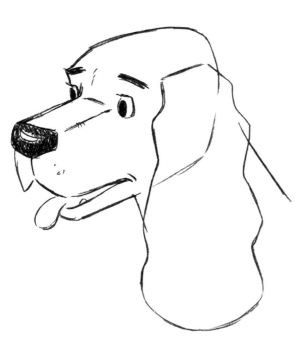

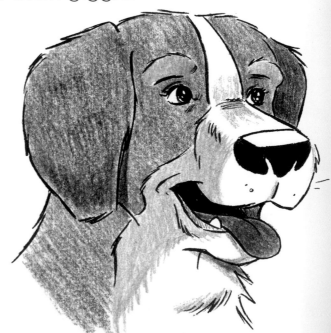

CLASSIC PROFILE

Most dogs' heads share the same basic construction. They have a boxy look that we'll modify as we draw. The head can be drawn along three levels. Let's take a look at a hound's head in profile to see how the levels line up.

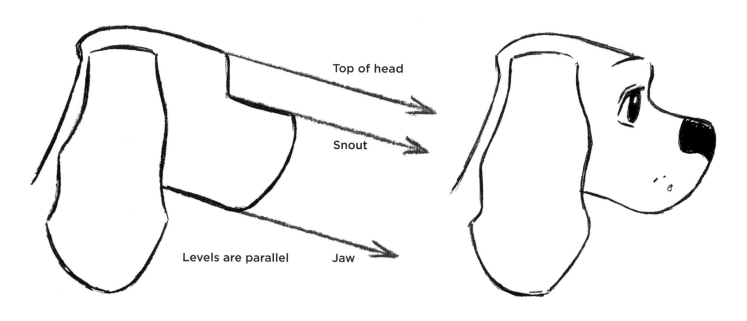

Top of head

Snout

Levels are parallel Jaw

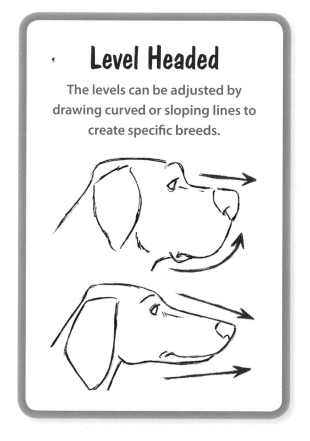

Level Headed

The levels can be adjusted by drawing curved or sloping lines to create specific breeds.

DRAWING THE MOUTH

Here are a couple of helpful hints for drawing the mouth in profile.

Interlocking Lips

When the mouth is closed, the upper and lower lip interlock. This is a natural position for the closed mouth. The back of the lips appears to droop a bit.

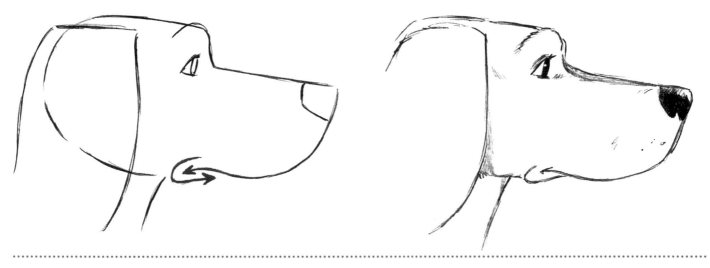

Concealed Mouth

On many breeds, the hair partially obscures our view of the mouth. This can get tricky to draw, so here's the secret: lightly sketch the entire mouth first, then draw the fur over it.

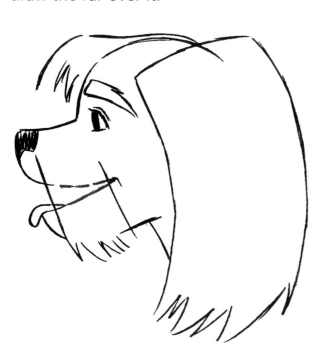

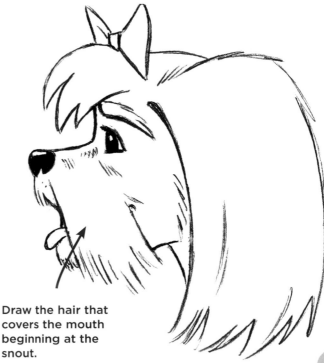

Draw the hair that covers the mouth beginning at the snout.

GOLDEN RETRIEVER

The golden retriever is a well-proportioned dog with a beautiful, soft coat of medium-length fur. It has a friendly, serene expression and sweet disposition that make it a favorite among dog lovers. We're going to draw our golden in a classic profile.

PET TRICK
Round off the forehead for that gentle "retriever" look.

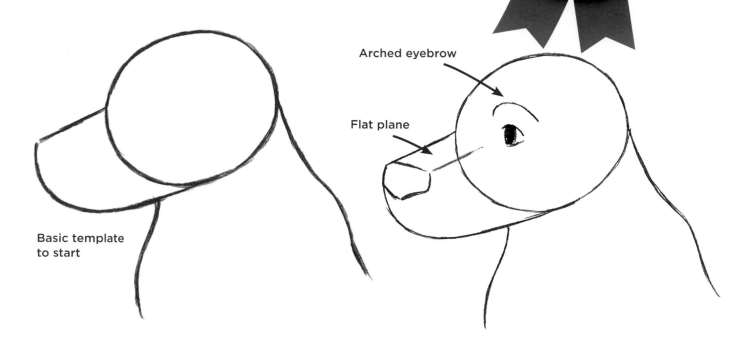

Basic template to start

Arched eyebrow

Flat plane

Extend the far eyebrow.

Highlight on top of nose

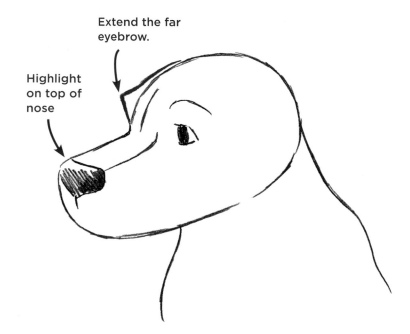

On the Nose

The chin peaks out from under the flappy upper lips, and the top of the nose is a flat plane.

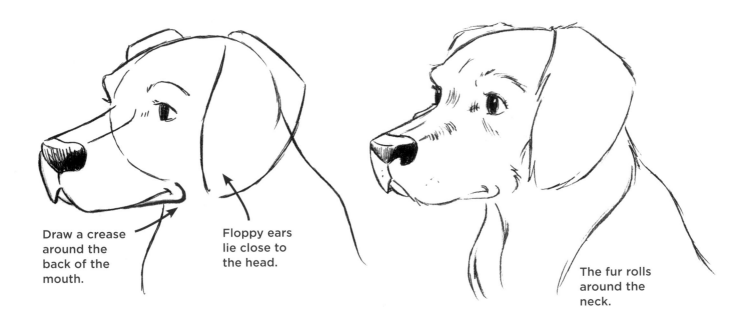

Draw a crease around the back of the mouth.

Floppy ears lie close to the head.

The fur rolls around the neck.

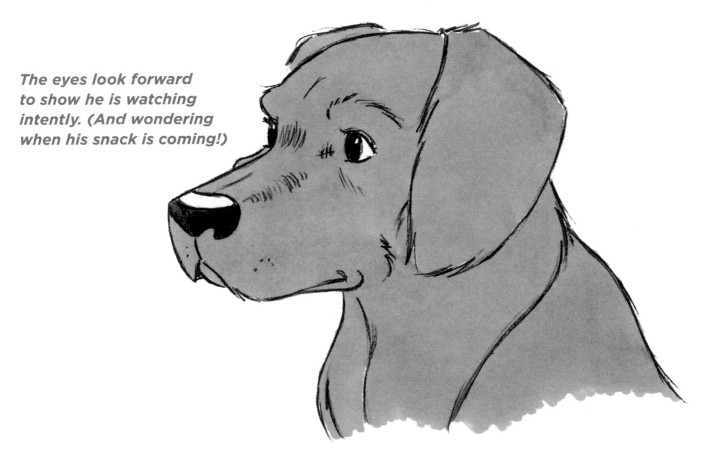

The eyes look forward to show he is watching intently. (And wondering when his snack is coming!)

COCKER SPANIEL

The cocker spaniel is one of the sweetest-looking dogs in the world, or maybe even the solar system. No, I'm going to go out on a limb and also include the star system of Alpha Centauri. (It's true, I've checked.) The cocker's dear look comes from three elements: big eyes; wide, rounded upper lip pads, and wavy, pendulum-shaped ears.

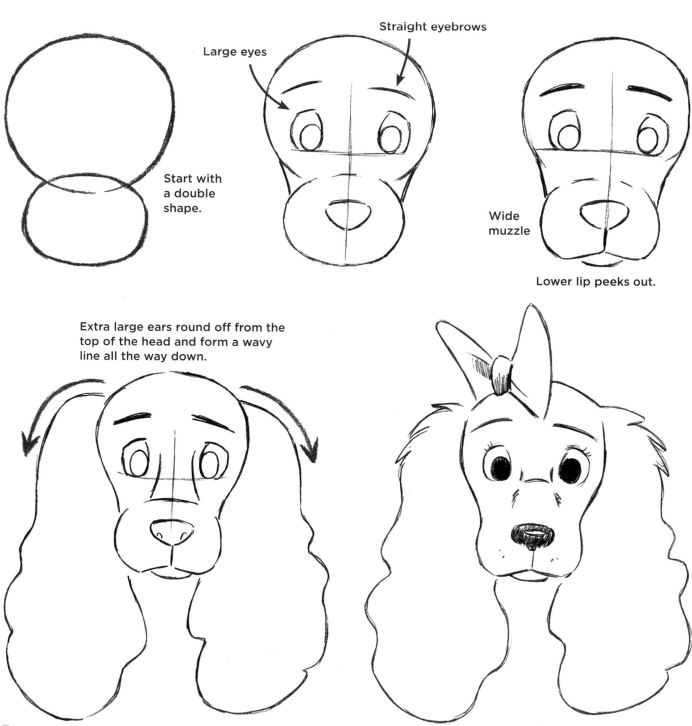

Start with a double shape.

Large eyes

Straight eyebrows

Wide muzzle

Lower lip peeks out.

Extra large ears round off from the top of the head and form a wavy line all the way down.

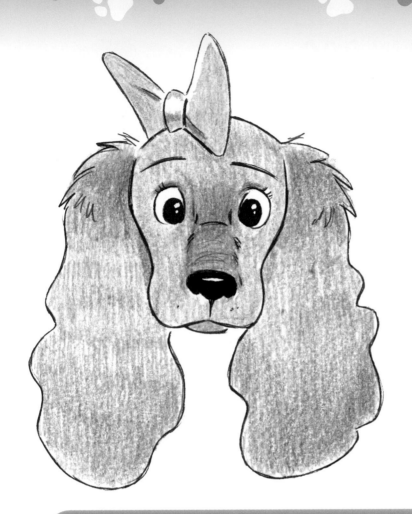

PET TRICK
I like to draw the cocker spaniel using gently curving lines for the construction of the head.

Color Variation

The golden-colored coat is the most common, but silver is also a beautiful color for this pet.

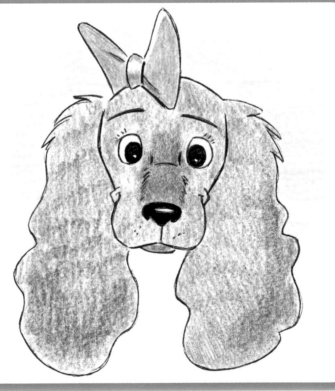

BERNESE MOUNTAIN DOG

It's amazing to think that twenty years ago this was a relatively rare breed in the United States. Now, these lovable, steady giants are everywhere. They have a dense tricolor coat and a cheerful expression.

PET TRICK
Use a dotted guideline to keep the middle of the forehead, muzzle, nose, and split upper lip in alignment.

The top of the head is flat and wide.

The eyes are relatively small.

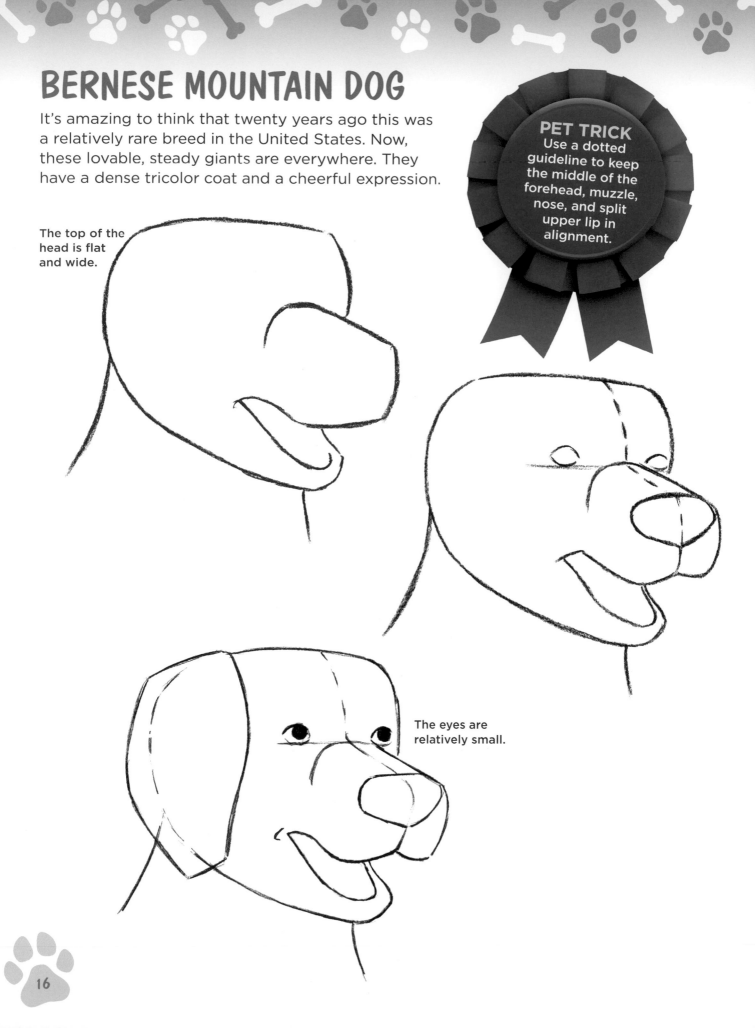

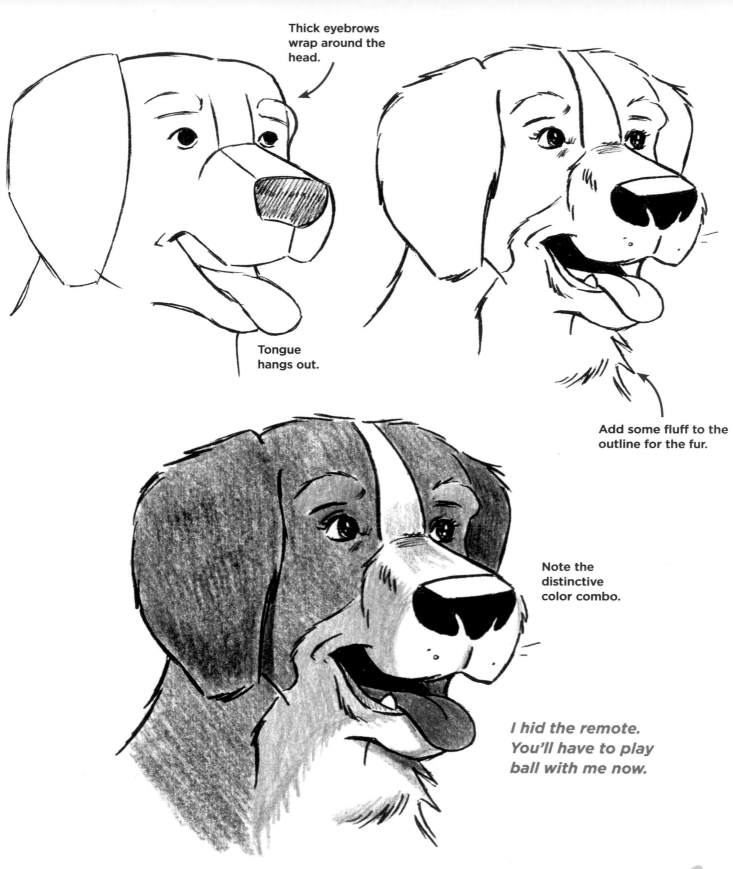

Thick eyebrows wrap around the head.

Tongue hangs out.

Add some fluff to the outline for the fur.

Note the distinctive color combo.

I hid the remote. You'll have to play ball with me now.

ENGLISH SPRINGER SPANIEL

The best known of the spaniel class and a perennial favorite in the show ring is the English springer spaniel. Appreciated for its tenacious hunting skills and cheerful disposition, the English springer is a very friendly dog and much-loved member of the family.

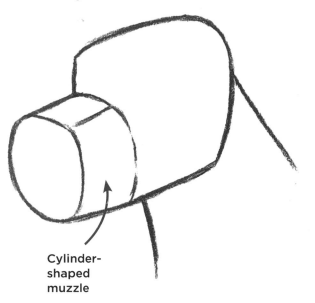

Cylinder-shaped muzzle

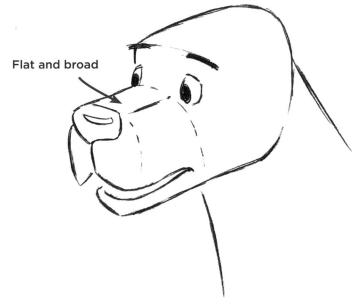

Flat and broad

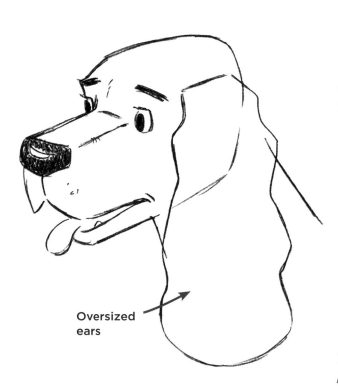

Oversized ears

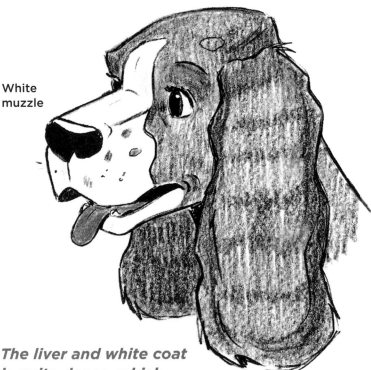

White muzzle

The liver and white coat is quite dense, which makes it bunch up a bit after a romp in the woods.

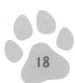

SAMOYED

Also known as the "smiling dog," this handsome Nordic working breed has a winning disposition. It is equally famous for its snow-white coat. Although the coat is coarse, to protect it against harsh winters, it always appears light and fluffy.

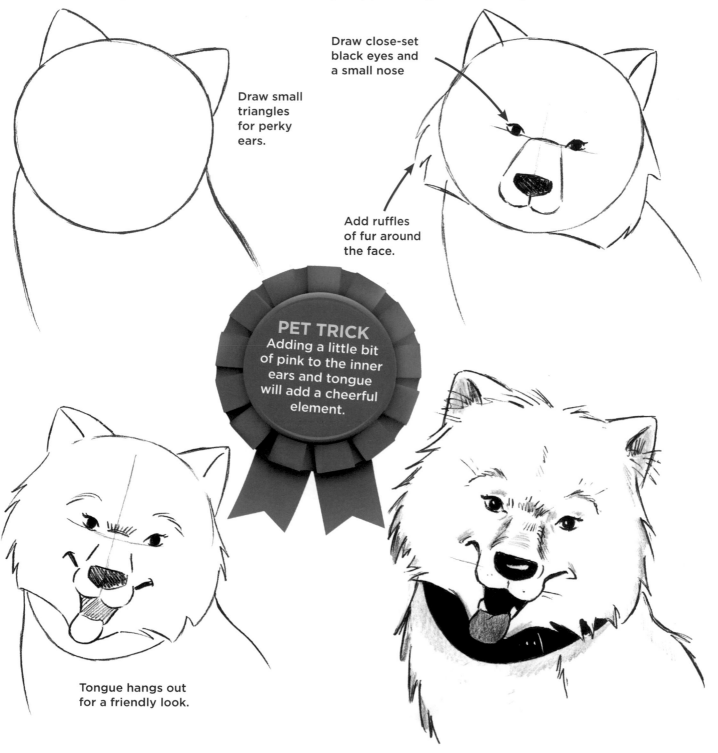

Draw small triangles for perky ears.

Draw close-set black eyes and a small nose

Add ruffles of fur around the face.

PET TRICK
Adding a little bit of pink to the inner ears and tongue will add a cheerful element.

Tongue hangs out for a friendly look.

BULLDOG

Humorous, compact, friendly, loyal. That's the ever-popular bulldog. The bulldog's head is massive, especially its jowls. The snout is close to the eyes, giving it a scrunched-up look. This results in prominent folds of skin above the bridge of the nose, which are admired by all bulldog lovers.

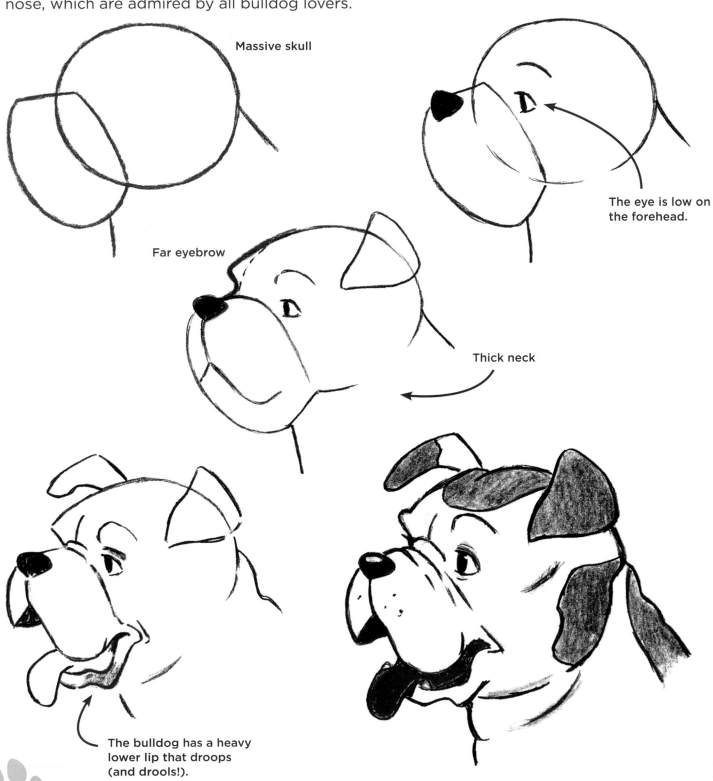

Massive skull

The eye is low on the forehead.

Far eyebrow

Thick neck

The bulldog has a heavy lower lip that droops (and drools!).

MIXED BREED

My first dog was a mixed breed—and my second, too. Mixed breeds have some of the best qualities of the pure breeds that make them up. This shaggy, friendly guy is drawn with a golden retriever's head construction, but with the scruffy coat of a griffon.

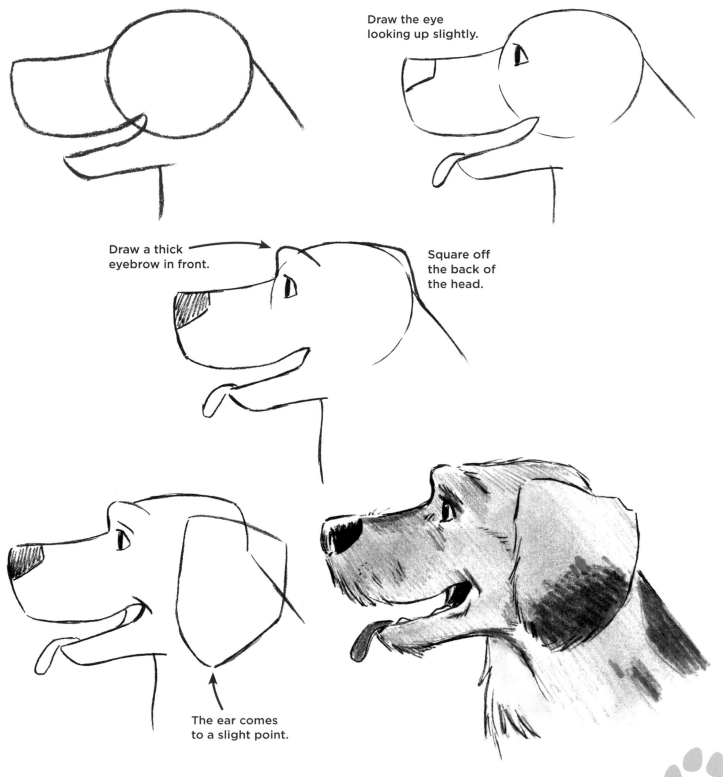

Draw the eye looking up slightly.

Draw a thick eyebrow in front.

Square off the back of the head.

The ear comes to a slight point.

FOXHOUND

The foxhound is a handsome, classic hunting dog. Its strong profile shows a rectangular muzzle and balanced proportions. The tan coat is rich in color but not too dark. All in all, this is a dignified dog.

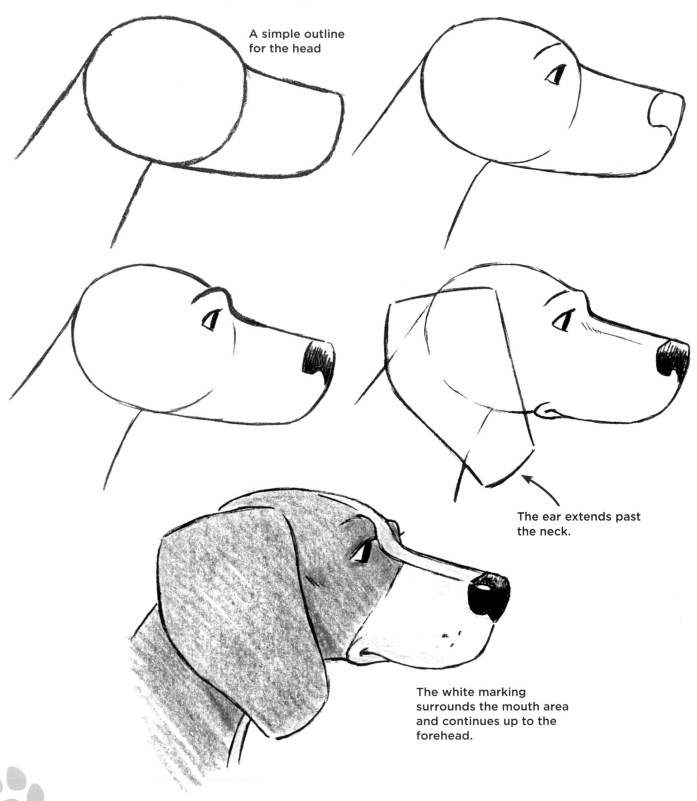

A simple outline for the head

The ear extends past the neck.

The white marking surrounds the mouth area and continues up to the forehead.

MINIATURE SCHNAUZER

The mini schnauzer has become one of the most popular dogs in the country. It has an admirable sense of self-confidence, given the fact that it weighs only about 15 pounds! It is "terrier" smart, with alert eyes and almost human expressions.

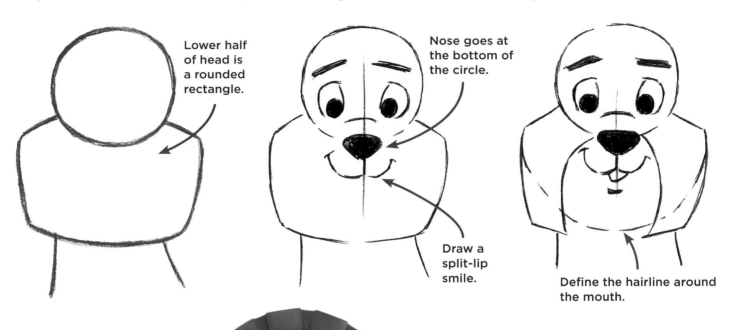

Lower half of head is a rounded rectangle.

Nose goes at the bottom of the circle.

Draw a split-lip smile.

Define the hairline around the mouth.

Draw two lines from the bridge of the nose up to the forehead.

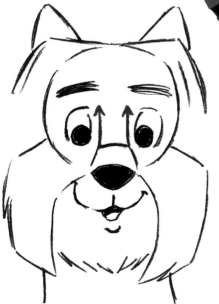

PET TRICK
Gray is neutral and therefore helps brighter colors, such as the green collar, stand out against it.

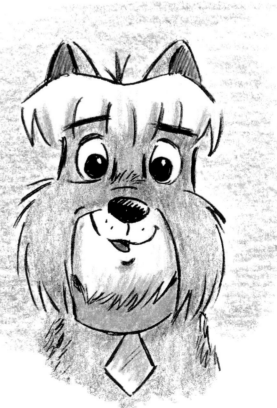

NEWFOUNDLAND

The Newfie is a whole lot of dog. And one of the largest breeds. It has a colossal forehead and giant, floppy ears. It's like a walking mountain of fur with a wagging tail.

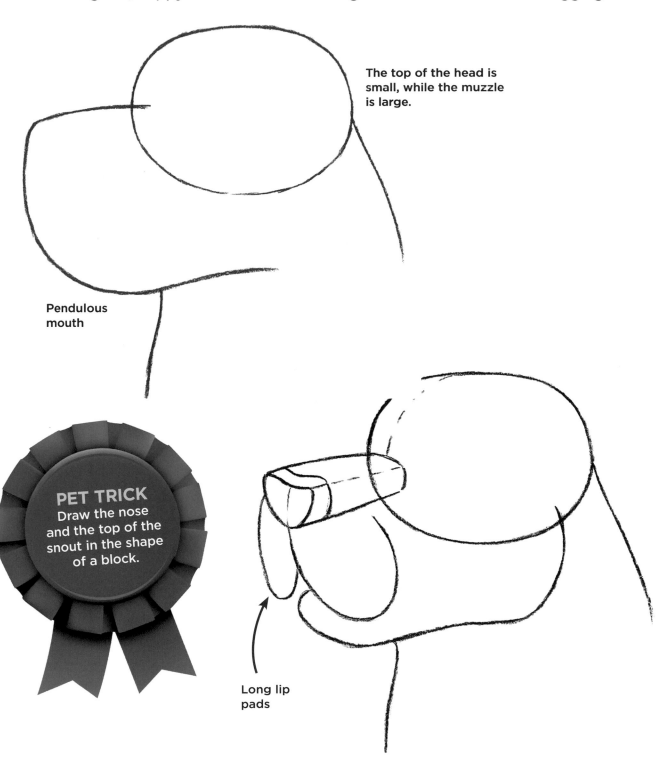

The top of the head is small, while the muzzle is large.

Pendulous mouth

PET TRICK
Draw the nose and the top of the snout in the shape of a block.

Long lip pads

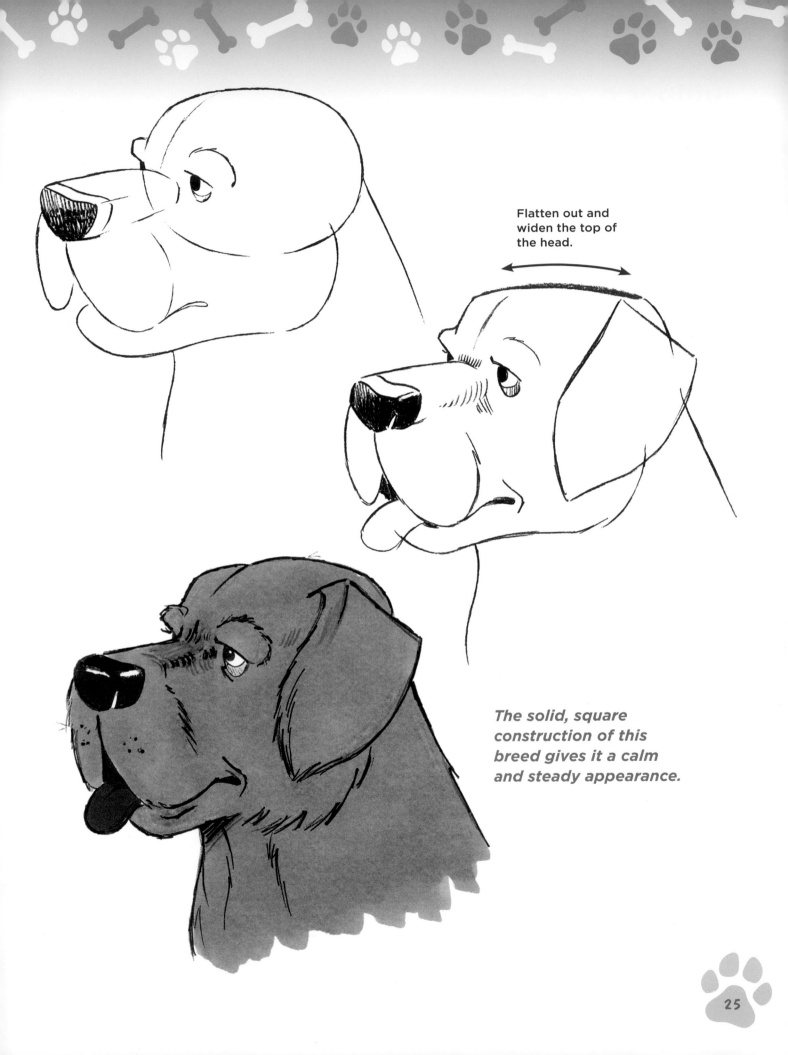

Flatten out and widen the top of the head.

The solid, square construction of this breed gives it a calm and steady appearance.

WHIPPET

The whippet is closely related to its larger cousin, the greyhound. Amazingly fast, the whippet has been reported to run up to 35 miles an hour. As you might expect, everything about them is sleek and aerodynamic. An old breed, they have been portrayed in oil paintings as far back as the mid-1700s.

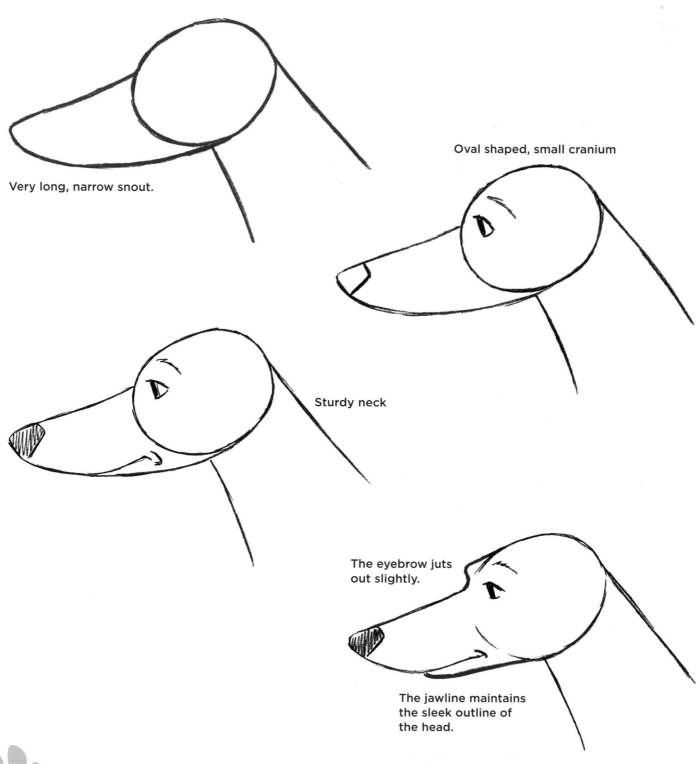

Very long, narrow snout.

Oval shaped, small cranium

Sturdy neck

The eyebrow juts out slightly.

The jawline maintains the sleek outline of the head.

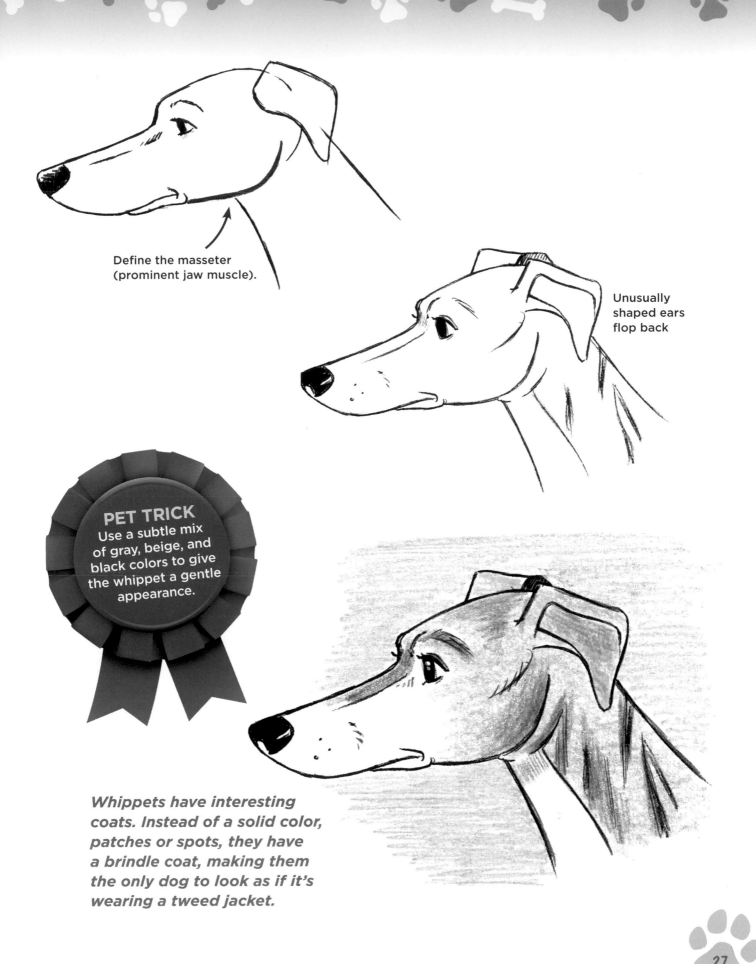

Define the masseter (prominent jaw muscle).

Unusually shaped ears flop back

PET TRICK
Use a subtle mix of gray, beige, and black colors to give the whippet a gentle appearance.

Whippets have interesting coats. Instead of a solid color, patches or spots, they have a brindle coat, making them the only dog to look as if it's wearing a tweed jacket.

MIXED TOY DOG

An appealing look for a mixed toy breed is a mop of hair on top of the head and bright eyes peeping out beneath. I've thickened this pup's mustache to give his appearance more impact.

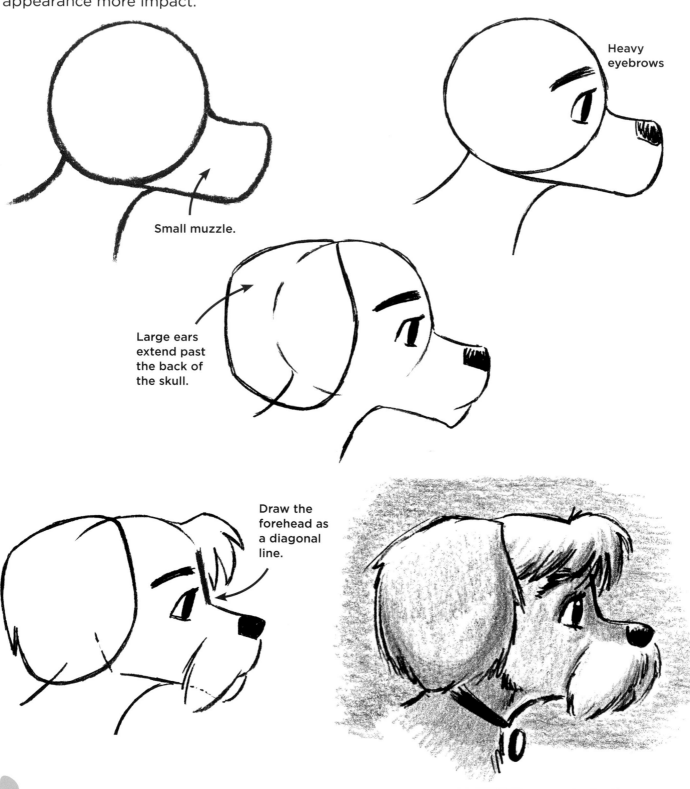

Small muzzle.

Heavy eyebrows

Large ears extend past the back of the skull.

Draw the forehead as a diagonal line.

BELGIAN SHEPHERD

The Belgian shepherd, also know as the Belgian Tervuren, is an impressive dog with a primarily brown coat. However, the head and neck have black mixed into the brown coloring, which gives it a dramatic appearance. It cuts a sleek silhouette.

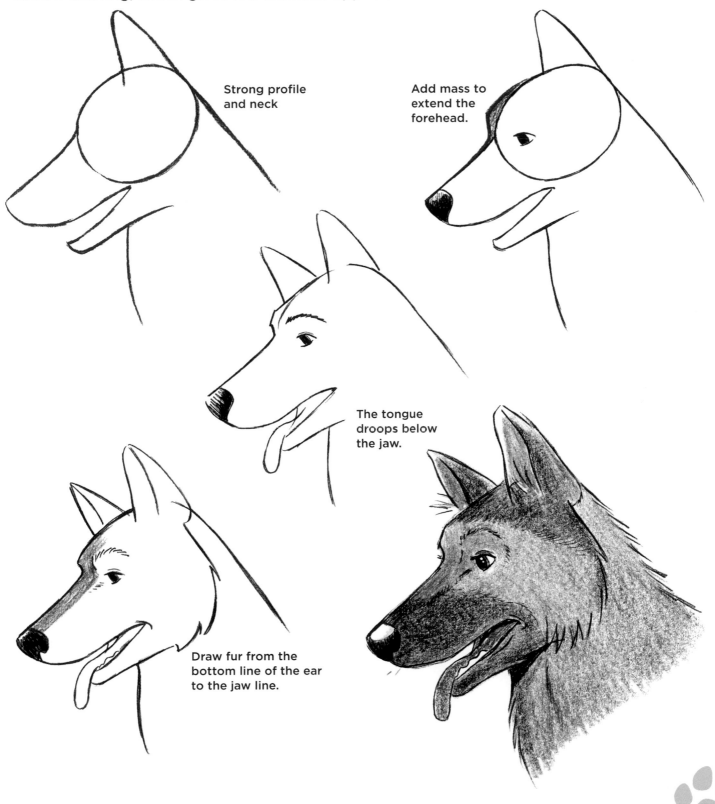

Strong profile and neck

Add mass to extend the forehead.

The tongue droops below the jaw.

Draw fur from the bottom line of the ear to the jaw line.

29

GIANT SCHNAUZER

The giant schnauzer is truly a giant. With a muscular neck and cropped ears (pointing straight up) he might seem intimidating, but those bushy eyebrows and oversized mustache soften the look.

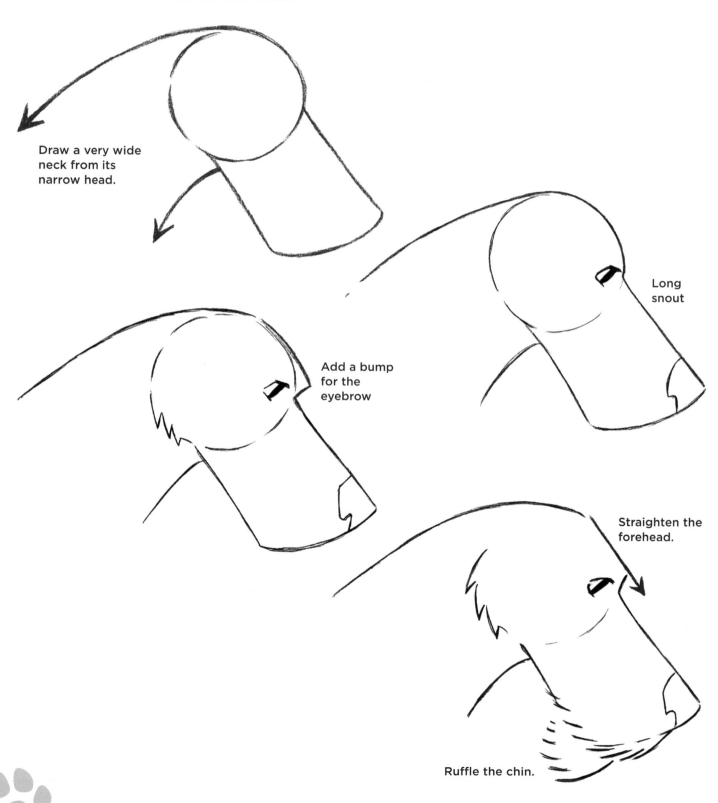

Draw a very wide neck from its narrow head.

Add a bump for the eyebrow

Long snout

Straighten the forehead.

Ruffle the chin.

Giant eyebrows on the giant schnauzer.

Ears point forward

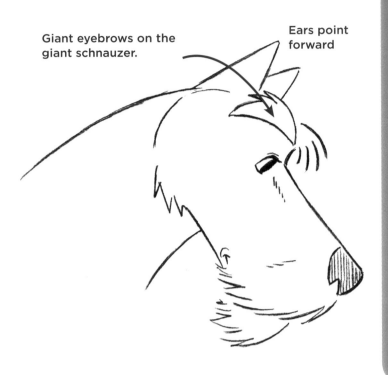

Grooming Tips

The key to drawing the giant schnauzer is in the grooming—specifically, these four areas:

- Bushy eyebrows
- Fur over the eyes
- "Mustache"
- Beard

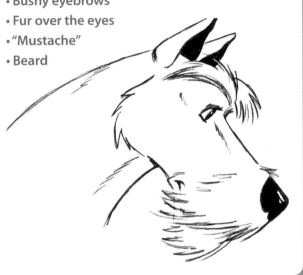

Pencil shading works well to mimic the color of the coat.

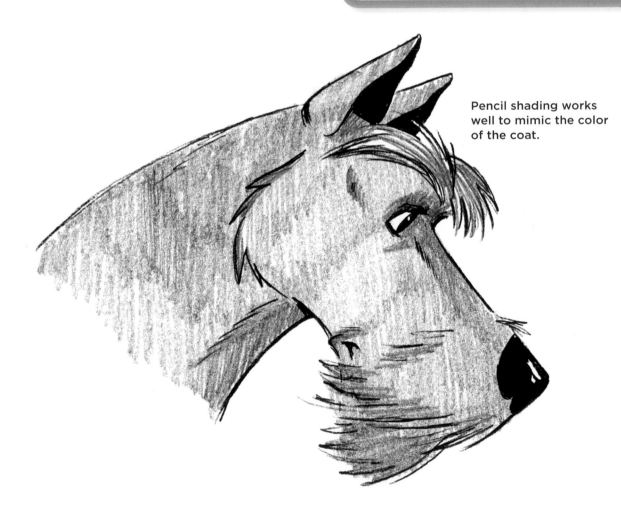

GREAT DANE

This lovable giant has a unique look based on its large nose and flews (upper lip area). Few people know this canine trivia, but, originally, it was called "Pretty Good Dane." As time passed, it became so popular that it was renamed "Great Dane." Don't quote me on that.

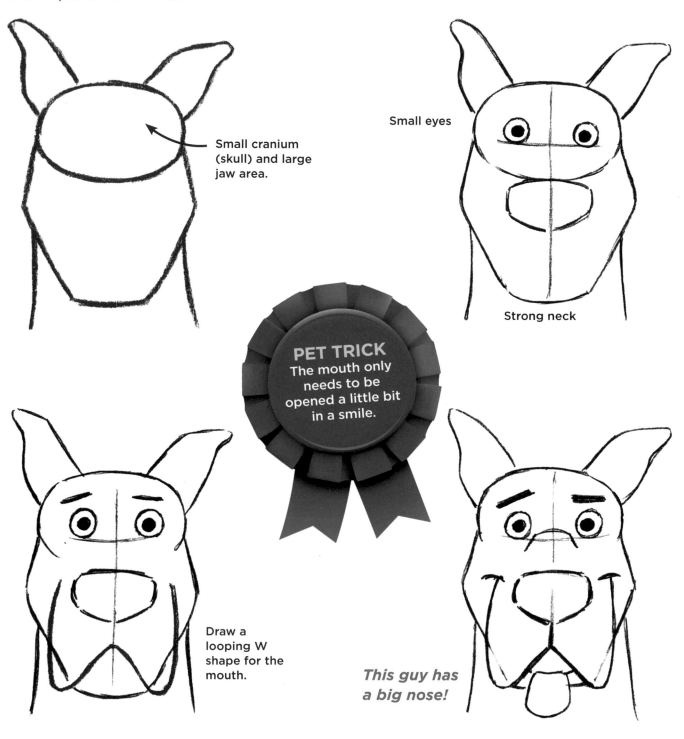

Small cranium (skull) and large jaw area.

Small eyes

Strong neck

PET TRICK
The mouth only needs to be opened a little bit in a smile.

Draw a looping W shape for the mouth.

This guy has a big nose!

Face Facts

Another way to look at drawing the Great Dane's face is to break it down into a tapered rectangle, then add some width to each side of the face.

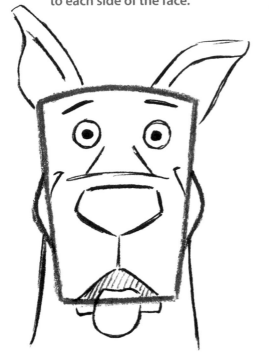

Draw irregularly shaped ears.

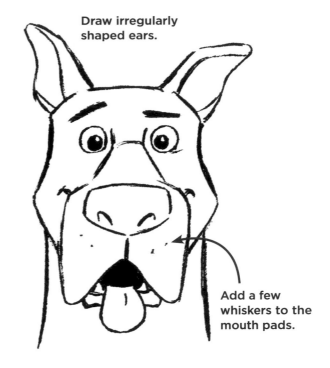

Add a few whiskers to the mouth pads.

Pizza's my favorite!

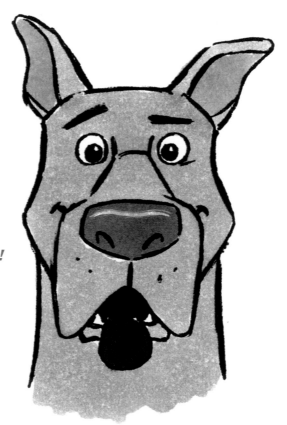

JACK RUSSELL

Feisty, driven, and an intrepid hunter, this small bundle of will power is a favorite pet among many dog-loving families. It is a well-proportioned, athletic dog —a classic terrier.

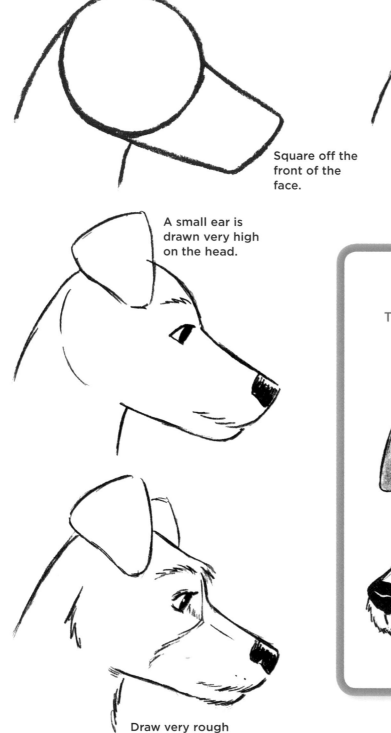

Square off the front of the face.

Squared-off muzzle

Small chin

A small ear is drawn very high on the head.

Draw very rough short hair.

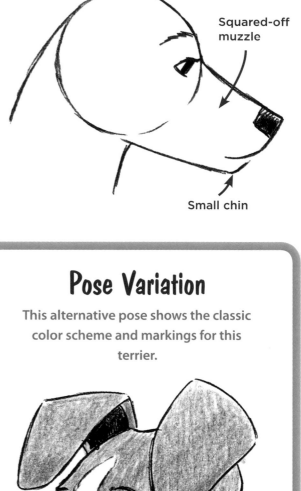

Pose Variation

This alternative pose shows the classic color scheme and markings for this terrier.

AMERICAN STAFFORDSHIRE TERRIOR

This fun-loving breed has a wide head, a long and curved snout, and eyes spaced widely apart. This puppy's eyes are somewhat almond shaped, giving it a sweet look. The coat is smooth.

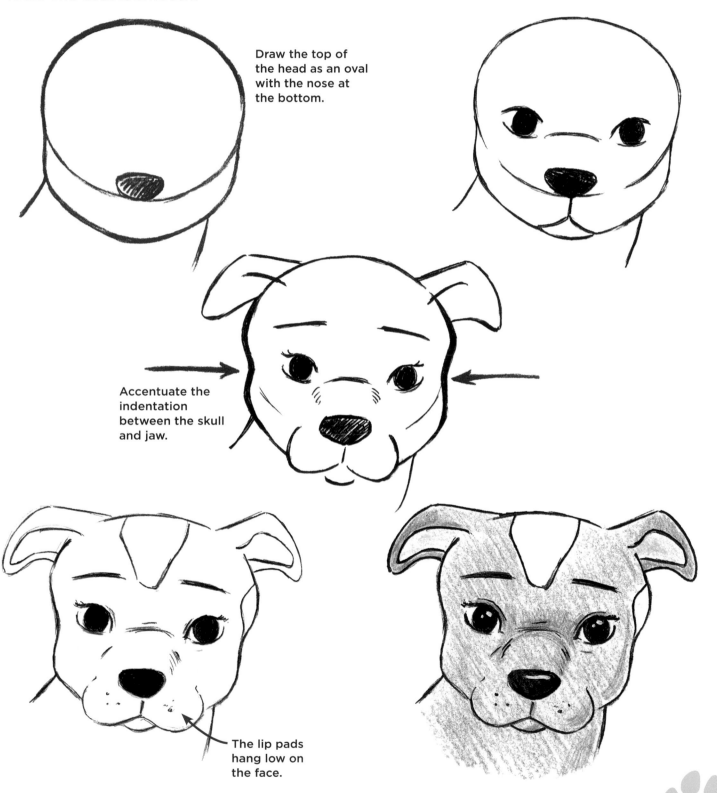

Draw the top of the head as an oval with the nose at the bottom.

Accentuate the indentation between the skull and jaw.

The lip pads hang low on the face.

SAINT BERNARD

The iconic Saint Bernard is truly a massive dog. Its distinctive tricolor markings, droopy eyes, and floppy mouth make him a favorite among dog fans everywhere. Drool is optional.

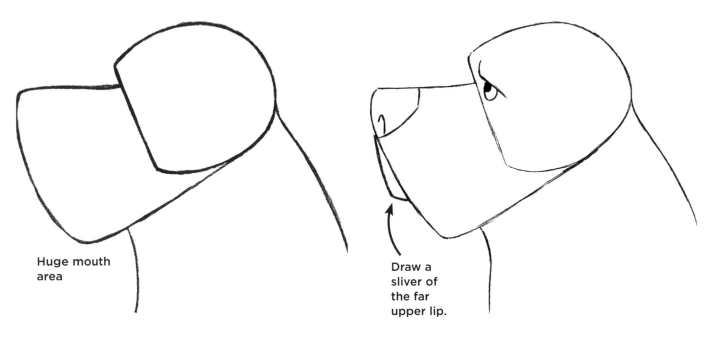

Huge mouth area

Draw a sliver of the far upper lip.

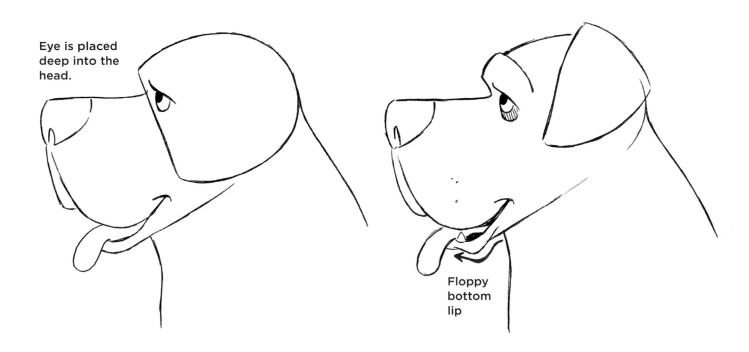

Eye is placed deep into the head.

Floppy bottom lip

Add a row of wrinkles to the brow.

Y Not?

The front view clearly shows the "split lip" that the Saint Bernard and other breeds have. It's drawn as an upside down Y shape.

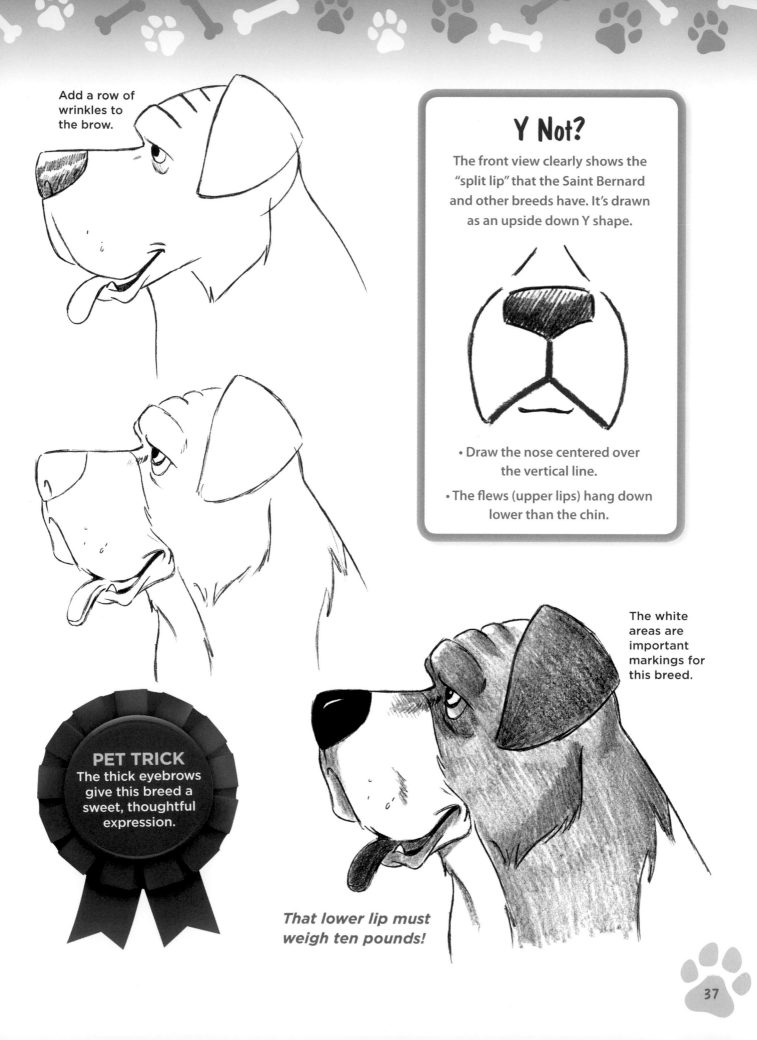

• Draw the nose centered over the vertical line.

• The flews (upper lips) hang down lower than the chin.

The white areas are important markings for this breed.

PET TRICK
The thick eyebrows give this breed a sweet, thoughtful expression.

That lower lip must weigh ten pounds!

SALUKI

The saluki is a rare breed with a graceful outline, a silky coat, and long, wispy ears. Its gently tapered muzzle, along with its silvery color, gives it an elegant profile.

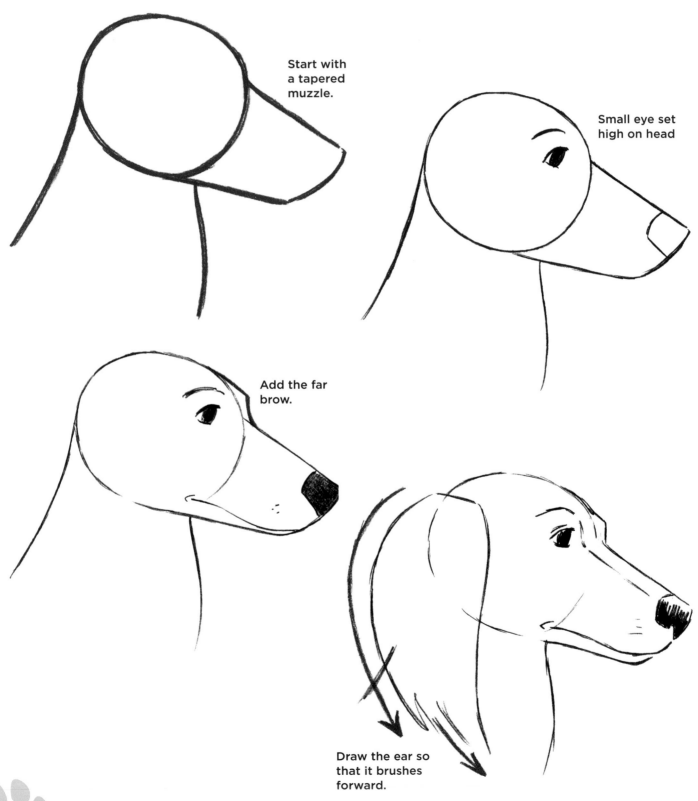

Start with a tapered muzzle.

Small eye set high on head

Add the far brow.

Draw the ear so that it brushes forward.

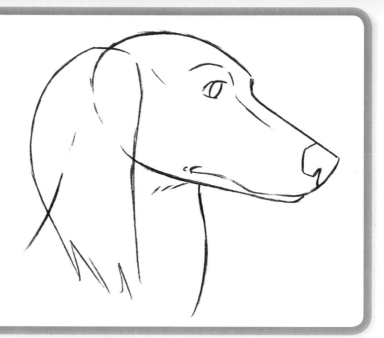

A Few More Hints

The rounded top of the head creates a gentle appearance, which continues into the long, curved ear. Keep in mind that its overall head shape is slender.

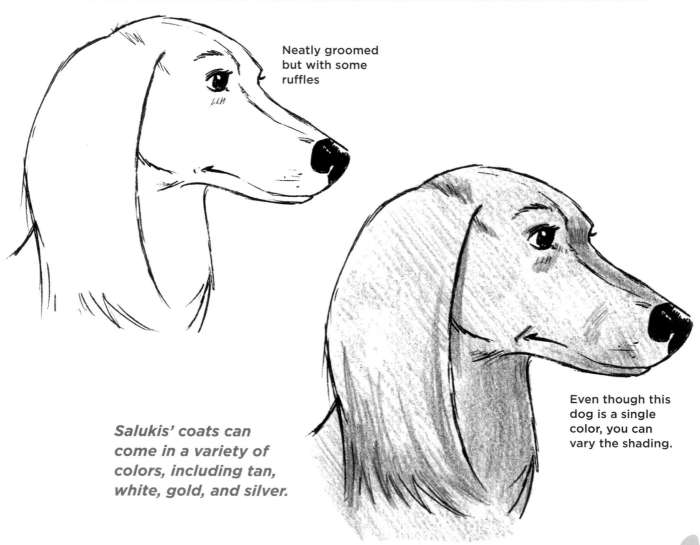

Neatly groomed but with some ruffles

Salukis' coats can come in a variety of colors, including tan, white, gold, and silver.

Even though this dog is a single color, you can vary the shading.

BULL TERRIER

He's a cheerful and clownish companion with a sweet-natured smile. He has an improbable head construction that gives him his unique (and popular!) appearance.

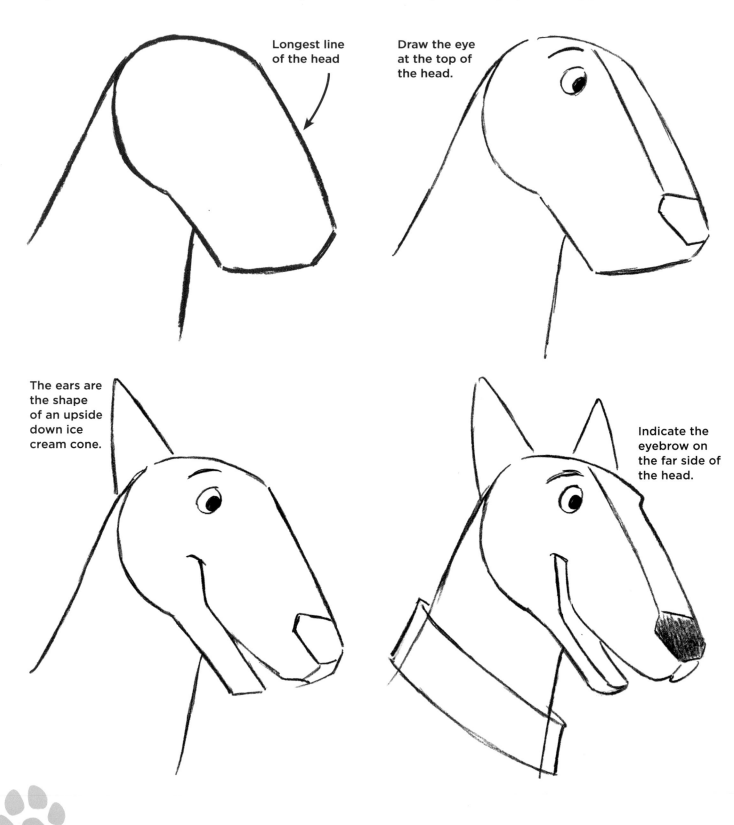

Longest line of the head

Draw the eye at the top of the head.

The ears are the shape of an upside down ice cream cone.

Indicate the eyebrow on the far side of the head.

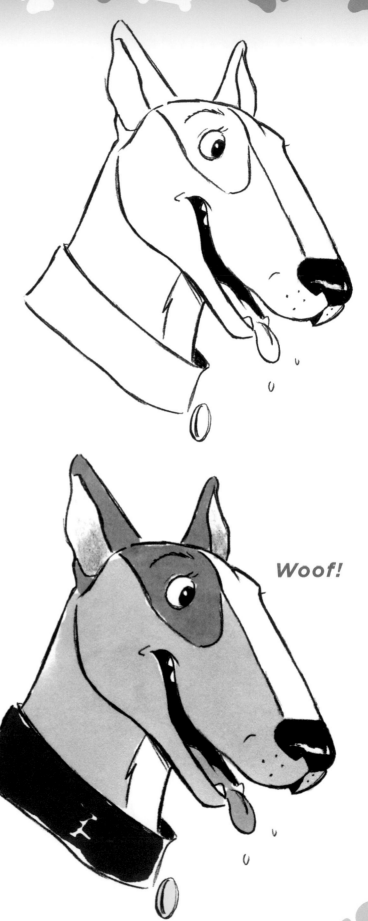

Sidebar Head?

The head is quite long. And remember, most of it is taken up by that funny grin. Both the head and the smile are drawn diagonally.

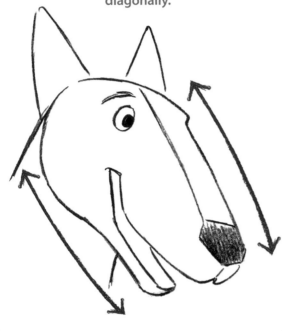

Woof!

41

CAIRN TERRIER

The cairn terrier flies a bit under the radar. Not as popular as the Westie (which is a white dog), the cairn nonetheless has many fans. This small Scottish dog has a rough coat and a happy stride. It appears to be endlessly curious. It also has a determined expression in the field.

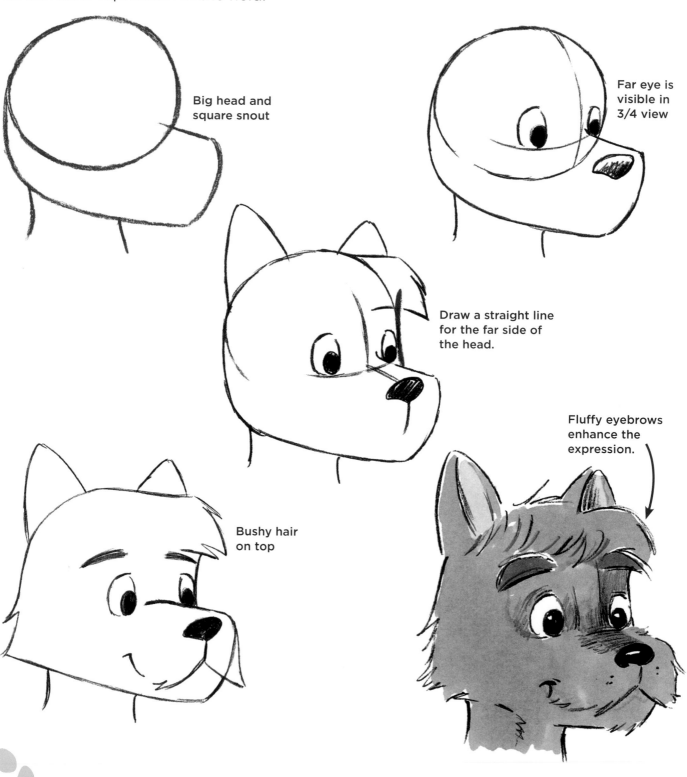

Big head and square snout

Far eye is visible in 3/4 view

Draw a straight line for the far side of the head.

Fluffy eyebrows enhance the expression.

Bushy hair on top

GERMAN SHEPHERD

Most people think of German shepherds as guard dogs. But I have seen many that are downright fun loving. I like to add that quality by drawing the German shepherd in a cartoon style.

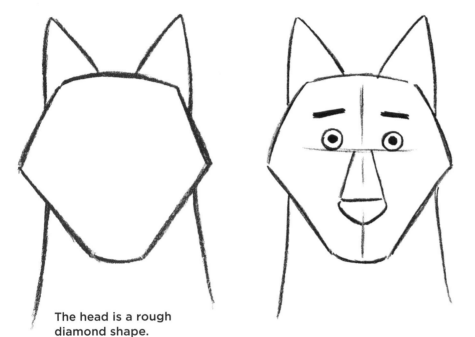

The head is a rough diamond shape.

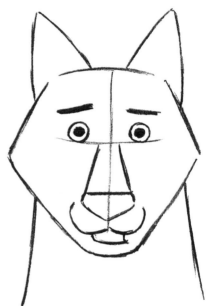

The mouth is slightly open.

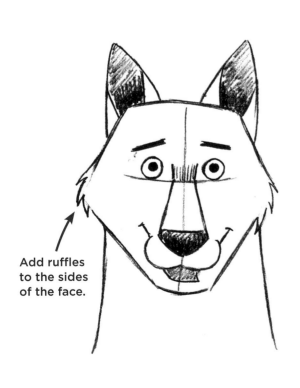

Add ruffles to the sides of the face.

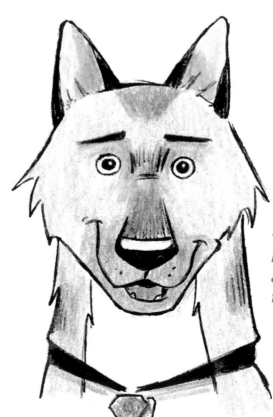

"This time, I'll toss it and you fetch!"

FUNNY HOUND

How long can an owner withstand that intense stare before caving and sharing his chicken sandwich? The longest anyone has held out is 55 seconds. Maybe someday the one-minute barrier will be broken.

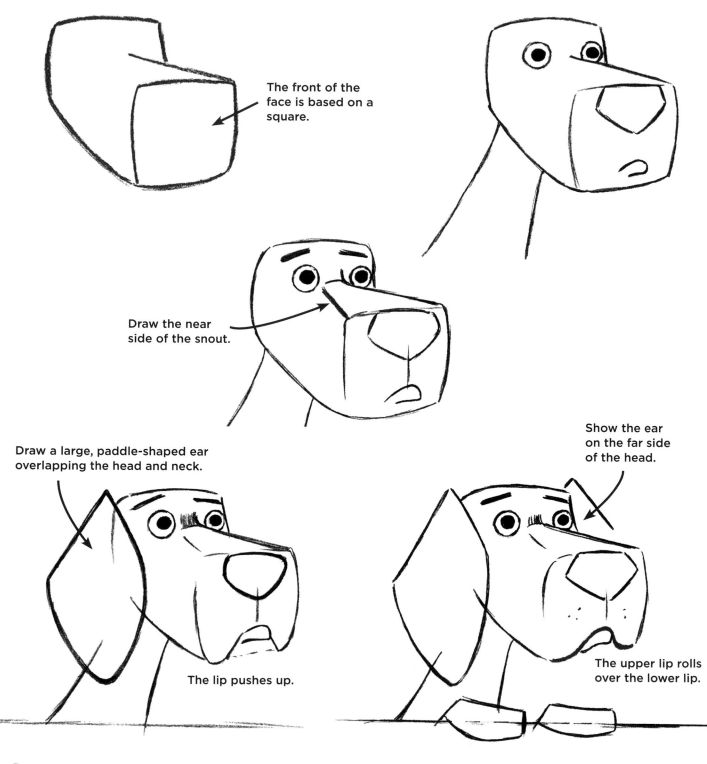

The front of the face is based on a square.

Draw the near side of the snout.

Draw a large, paddle-shaped ear overlapping the head and neck.

The lip pushes up.

Show the ear on the far side of the head.

The upper lip rolls over the lower lip.

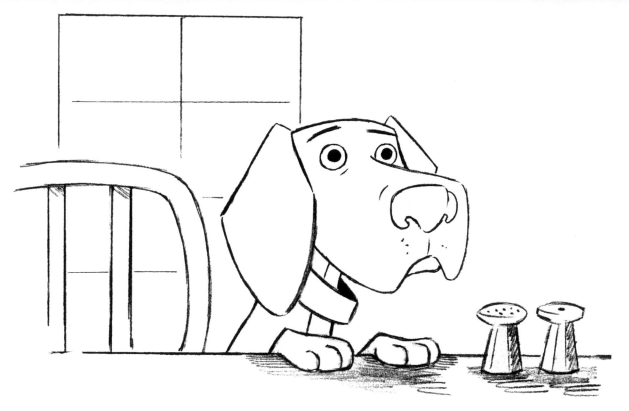

Add shading to indicate the surface of the table.

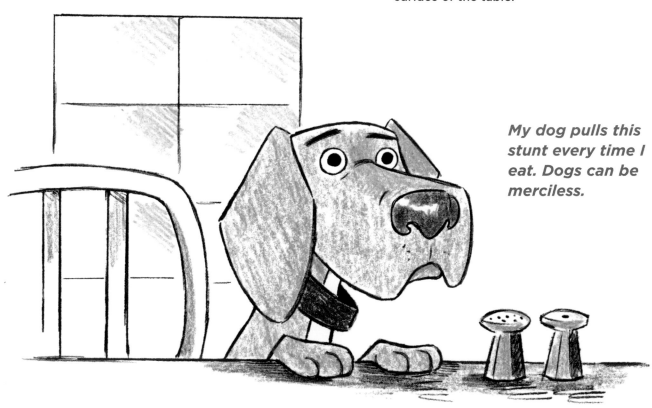

My dog pulls this stunt every time I eat. Dogs can be merciless.

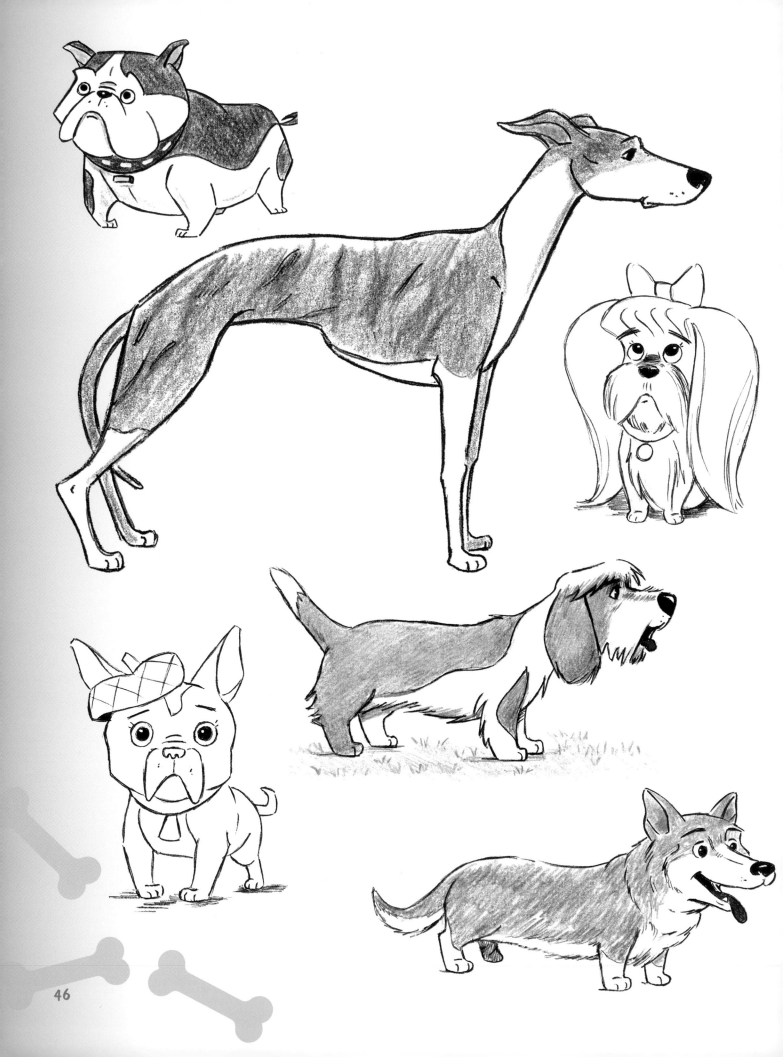

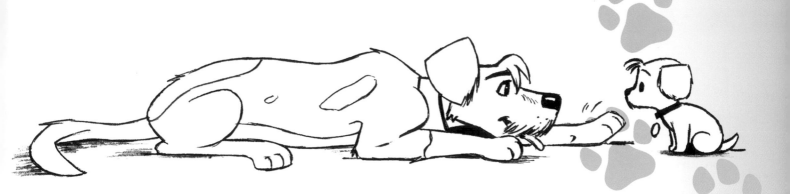

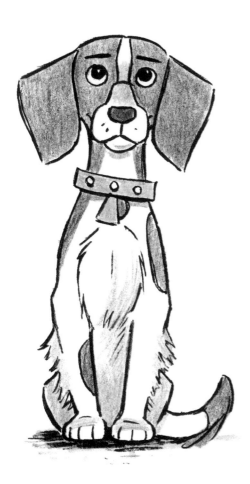

DRAWING DOGS
FULL BODIES

Whether it's a Great Dane or miniature schnauzer, all dogs have the same basic anatomy, however the proportions can be vastly different. This chapter will point out the differences and show you how to adjust the construction to create all your favorite pure and mixed breeds in plenty of playful poses.

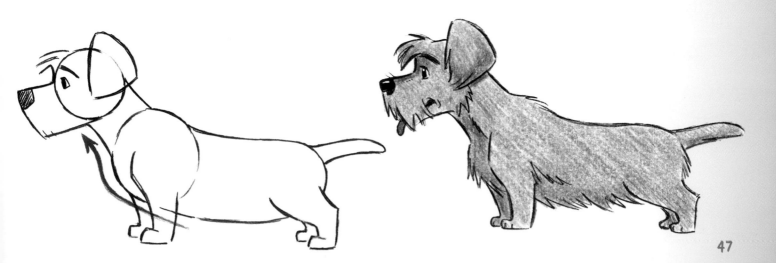

BODY BASICS

Let's start with a few hints that will make your drawings more lifelike. They work with almost any breed you can imagine.

Big and Small

The emphasis is placed on different parts of the body for adult dogs and puppies. Fortunately, it's easy to simplify.

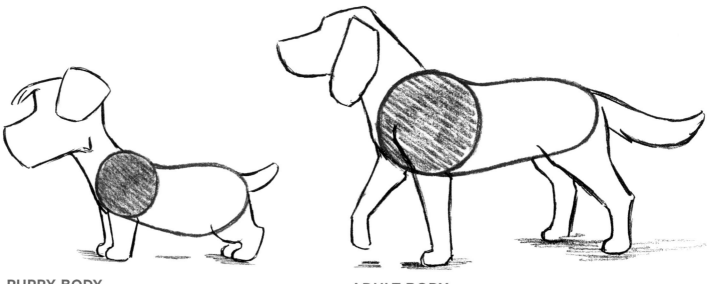

PUPPY BODY
On puppies, the chest area is generally smaller than the rump.

ADULT BODY
For adult dogs, the chest is larger than the hind section.

Shoulders and Hips

With the exception of bulldogs, the shoulders are less massive than the thigh area. This proportion is generally seen throughout different poses.

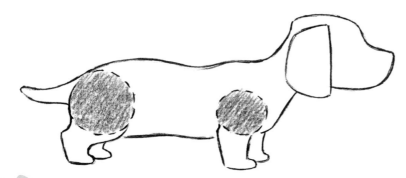

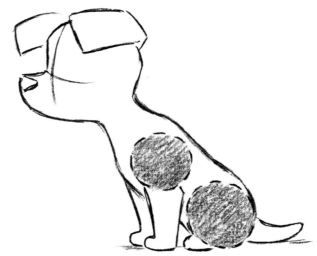

Leg Positions

The natural position of the front legs is straight up and down, while the rear legs sweep back from the hips. The hind legs are not positioned directly under the hips in the way that the forearms are directly under the shoulders. The rear feet are back farther.

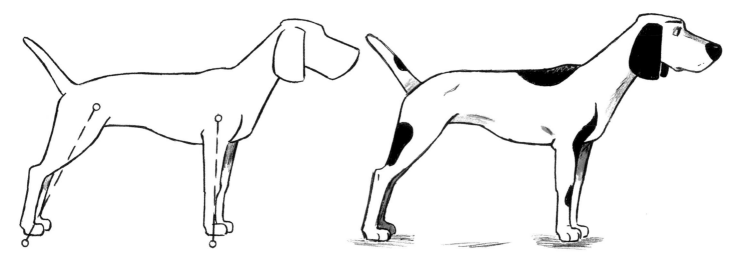

Important Contours

Two of the most prominent contours of the dog's body are the crest of the shoulders and a robust chest. These contours are diagonally across from each other and add balance to the form.

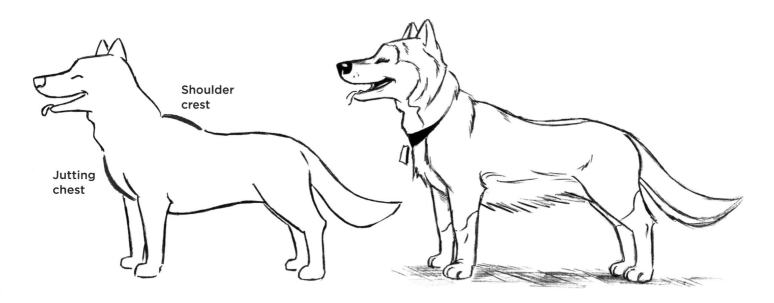

Shoulder crest

Jutting chest

PORTUGUESE WATER DOG

The name "water dog" gives you a clue to the look of the coat. Its coat is short, dense, and curly, which allows the Portuguese water dog to maintain body heat in the water. This is an athletically built dog, but its scruffy, family-friendly face gives it charm.

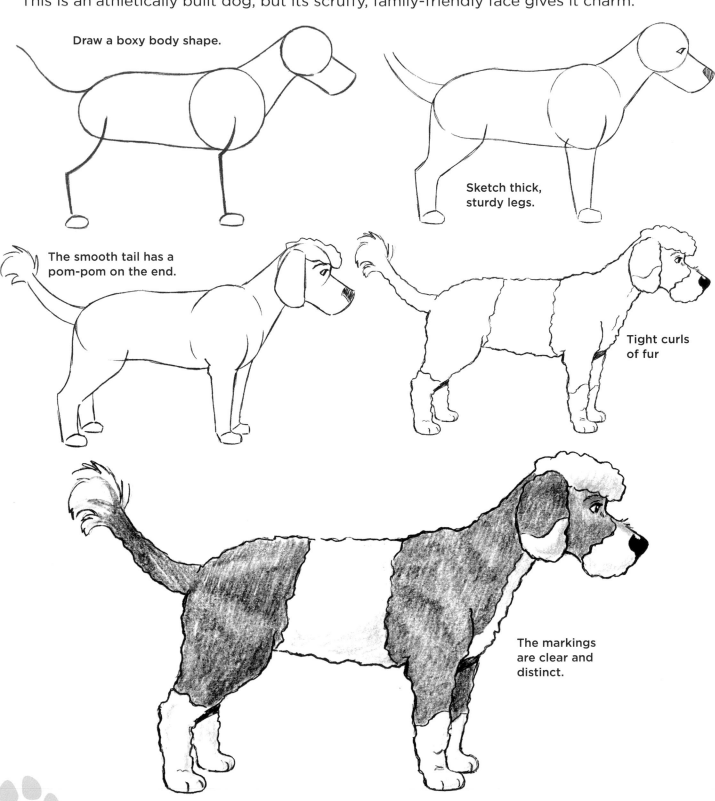

Draw a boxy body shape.

Sketch thick, sturdy legs.

The smooth tail has a pom-pom on the end.

Tight curls of fur

The markings are clear and distinct.

NORFOLK TERRIER

Though little, the Norfolk terrier is mighty and tenacious. You can see that plucky spirit in its stance and expression. If it were bigger, the Norfolk terrier would rule the world. That might not be the worst idea. But for now, we'll have to settle for it being a fantastic pet.

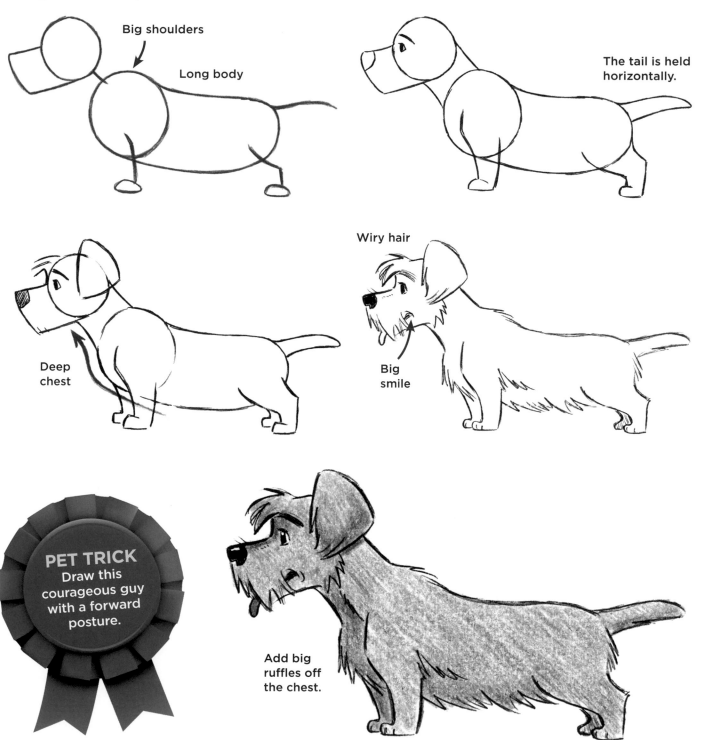

Big shoulders

Long body

The tail is held horizontally.

Deep chest

Wiry hair

Big smile

PET TRICK
Draw this courageous guy with a forward posture.

Add big ruffles off the chest.

BERNESE MOUNTAIN DOG

The Bernese mountain dog has such an affable demeanor that you overlook the fact that it's a very large dog that can weigh in at over 100 pounds. It has a dense coat with distinctive markings. We drew the head in the last chapter. Now let's take a look at how to draw the body.

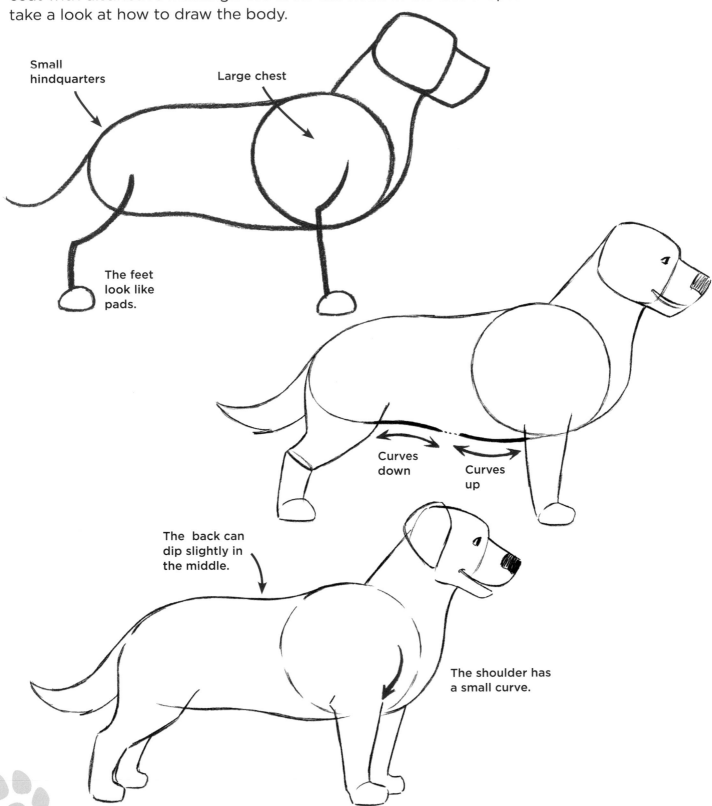

Small hindquarters

Large chest

The feet look like pads.

Curves down

Curves up

The back can dip slightly in the middle.

The shoulder has a small curve.

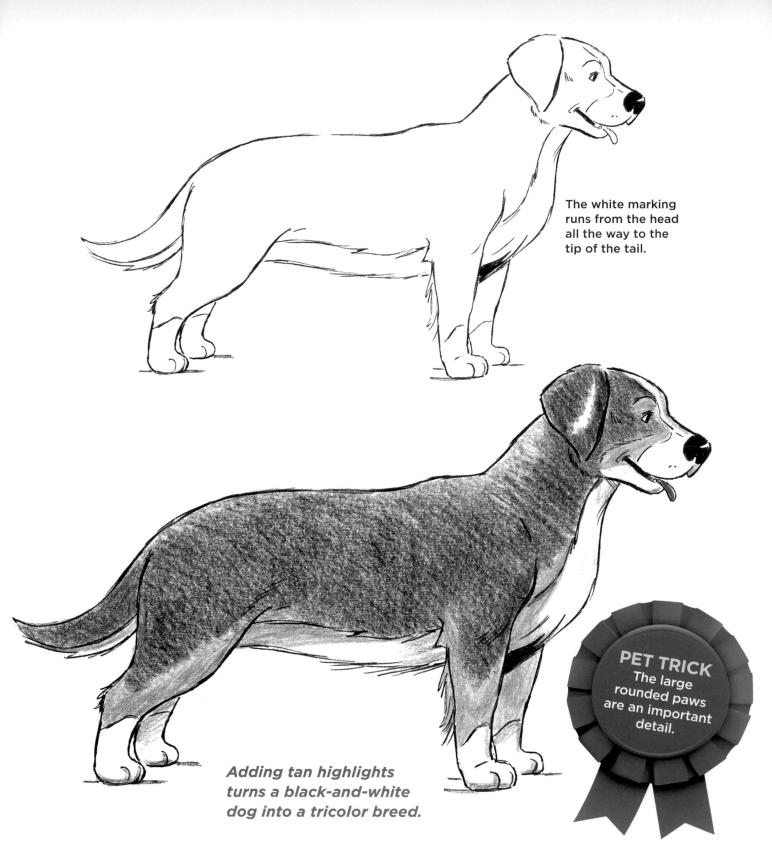

The white marking runs from the head all the way to the tip of the tail.

Adding tan highlights turns a black-and-white dog into a tricolor breed.

PET TRICK
The large rounded paws are an important detail.

PUG

Hugely popular, the pug is a fun-loving pet that lives to amuse. It's a toy dog with a big temperament ranging from stubborn to playful. Its furrowed brow gives it lots of expression.

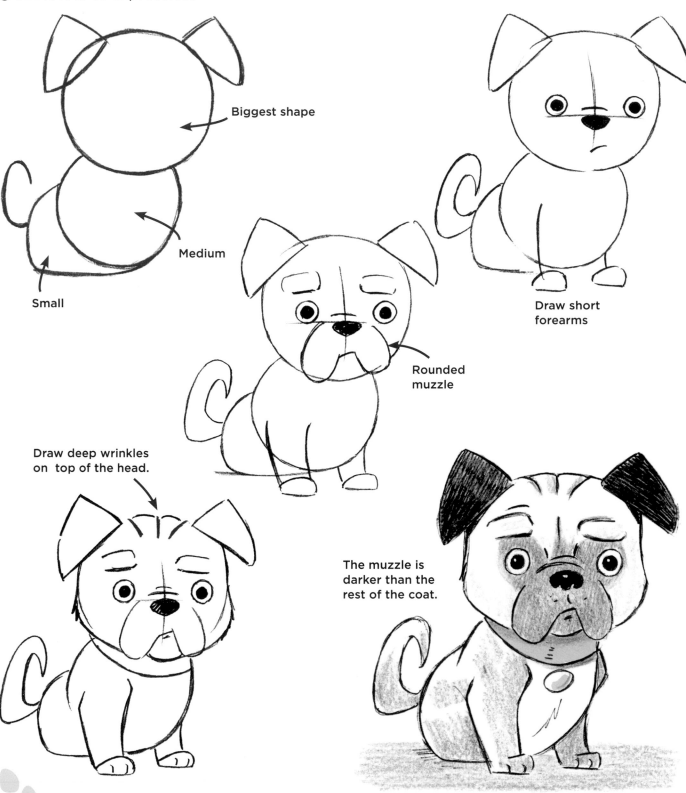

Biggest shape

Medium

Small

Rounded muzzle

Draw short forearms

Draw deep wrinkles on top of the head.

The muzzle is darker than the rest of the coat.

POMERANIAN

Some dogs look as if they enjoy every single day. That's the Pomeranian. This little bundle of furry friendliness has an optimistic expression and a peppy walk. The profuse coat appears well groomed, yet somewhat untamed.

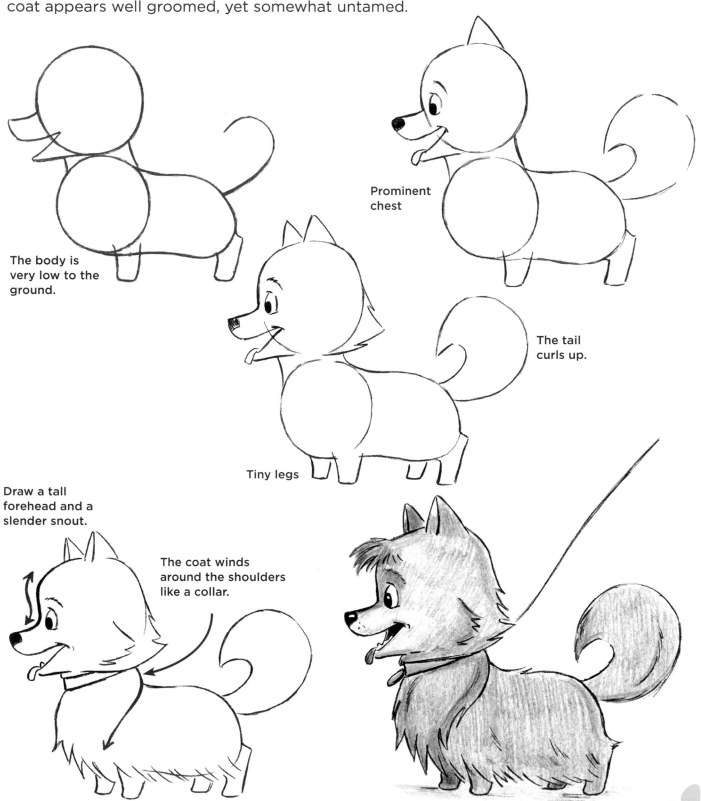

The body is very low to the ground.

Prominent chest

The tail curls up.

Tiny legs

Draw a tall forehead and a slender snout.

The coat winds around the shoulders like a collar.

HUSKY

When I was a kid, I wanted a husky. I wanted to sled through the woods with my husky out in the neighborhood, bounding over the snowy hills on the way to Grandmother's house. But we lived in Brooklyn. No one wanted to visit my grandmother, either. Well, at least I still get to draw huskies.

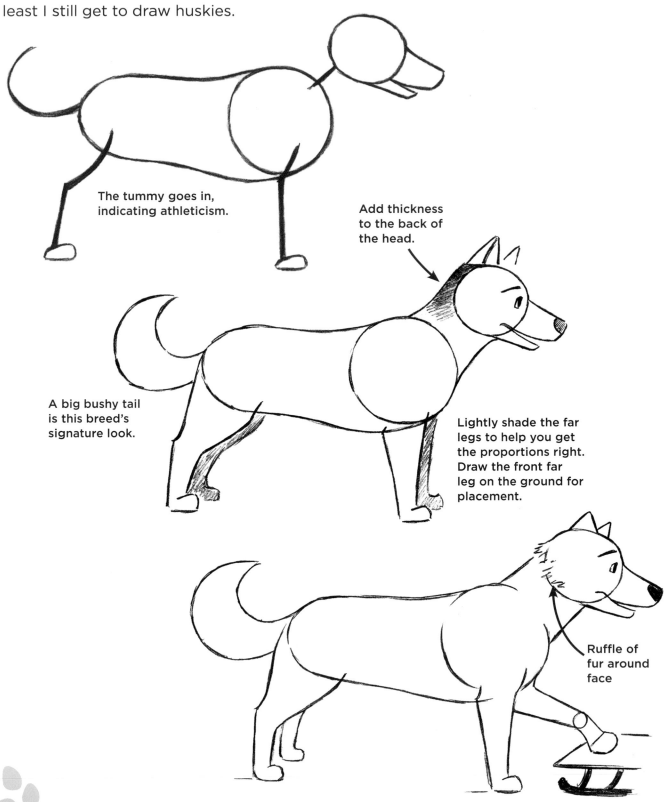

The tummy goes in, indicating athleticism.

Add thickness to the back of the head.

A big bushy tail is this breed's signature look.

Lightly shade the far legs to help you get the proportions right. Draw the front far leg on the ground for placement.

Ruffle of fur around face

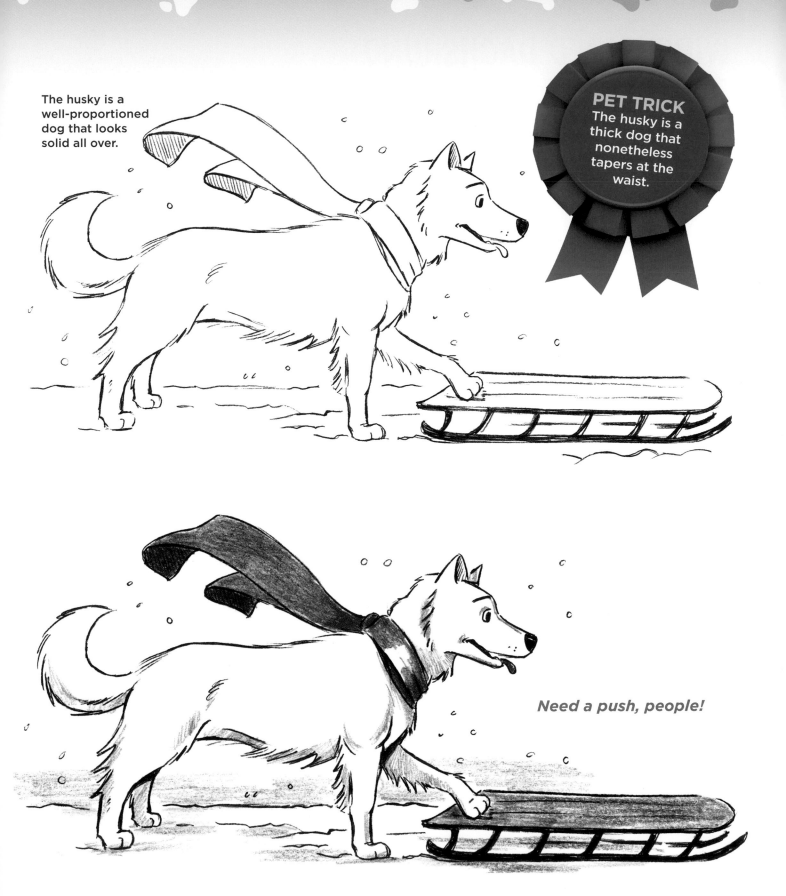

The husky is a well-proportioned dog that looks solid all over.

PET TRICK
The husky is a thick dog that nonetheless tapers at the waist.

Need a push, people!

WIREHAIRED DACHSHUND

Tough, scrappy, playful, and exuberant—that's a lot for such a little package! The wirehaired dachshund may have amusing proportions, but he's perfectly built for his job of flushing out small animals and wrestling your dress shoes to the ground.

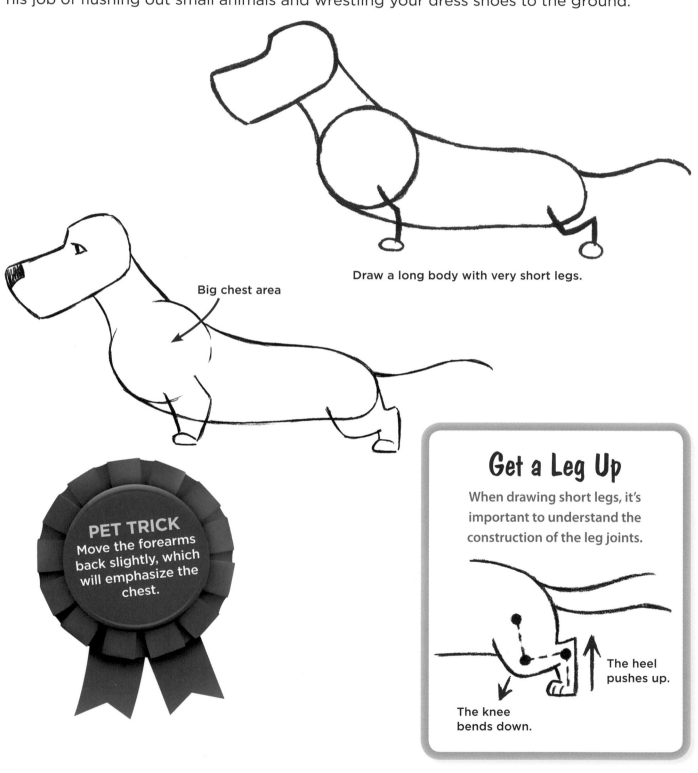

Draw a long body with very short legs.

Big chest area

PET TRICK
Move the forearms back slightly, which will emphasize the chest.

Get a Leg Up

When drawing short legs, it's important to understand the construction of the leg joints.

The heel pushes up.

The knee bends down.

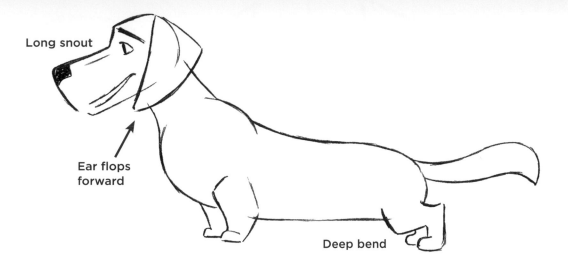

Long snout

Ear flops
forward

Deep bend

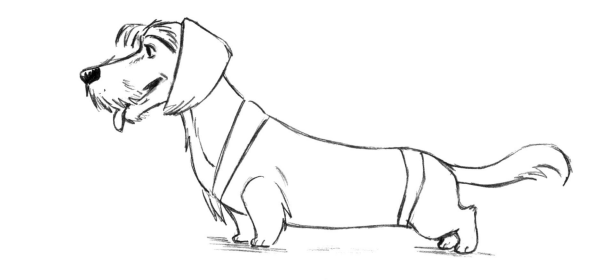

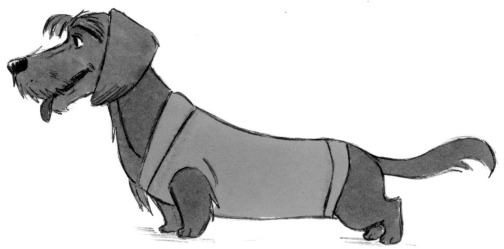

BRITTANY

The Brittany is a high-energy hunting dog with an athletic frame and a cheerful countenance. It's also great at catching a ball, fetching the newspaper, and rolling over so you can scratch its tummy. That's an important skill to have!

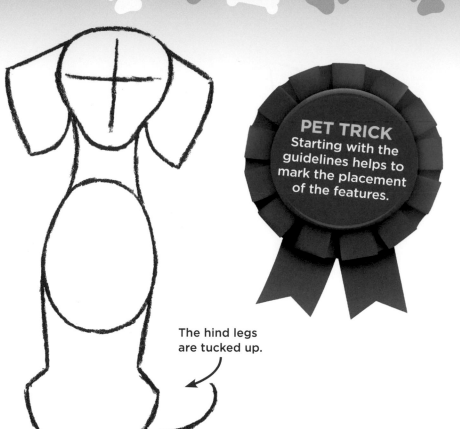

The hind legs are tucked up.

The ears slope.

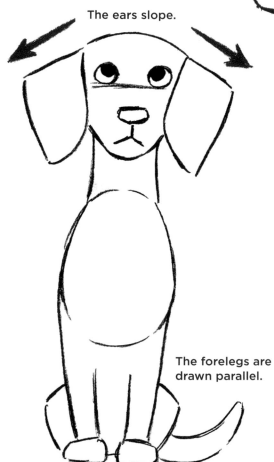

The forelegs are drawn parallel.

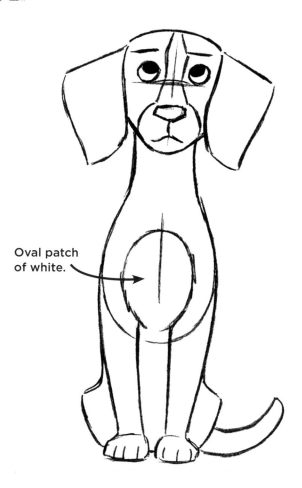

Oval patch of white.

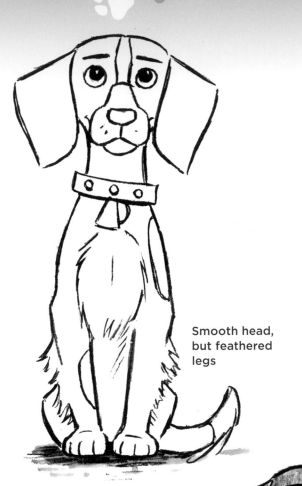

Smooth head, but feathered legs

Fringe Benefits

Feathering only happens on the back of the limbs, not the front.

Orange markings on the body and tail

If he wants to play, he will sit like this for hours until you can't take it any longer.

PETIT BASSET GRIFFON VENDÉEN

The Petit Basset Griffon Vendéen is a rare breed. Unlike its famous cousin, the adorably languorous basset hound, the Vendéen is a robust dog that likes to run, play, and hunt. Draw a cheerful, eager expression along with its improbable proportions.

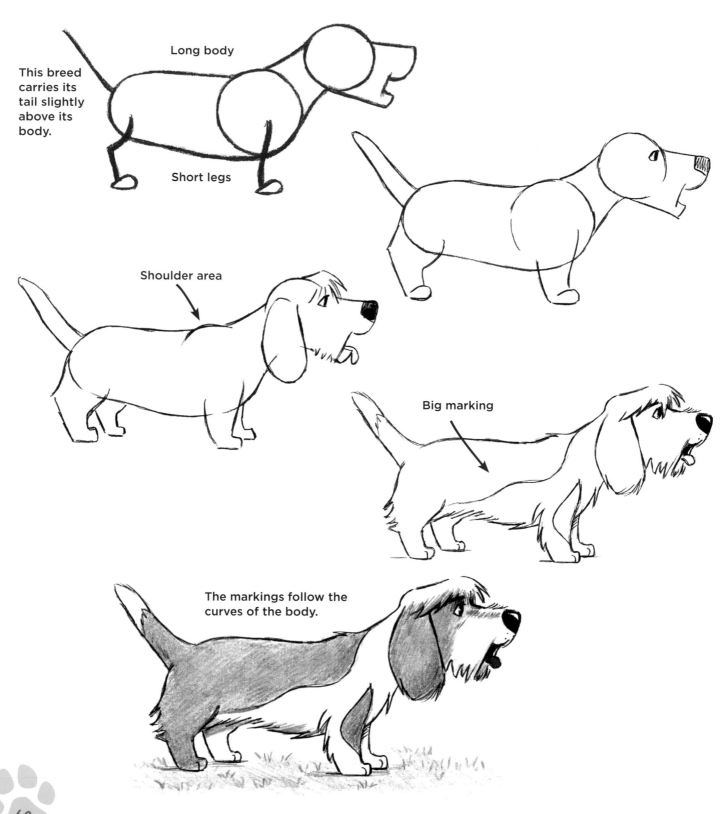

Long body

This breed carries its tail slightly above its body.

Short legs

Shoulder area

Big marking

The markings follow the curves of the body.

ENGLISH BULLDOG

The English bulldog has a unique look that has earned it a devoted following among dog lovers. Despite that scrunched face, its expression is sweet and softhearted. The slightly awkward body proportions give it a humorous charm.

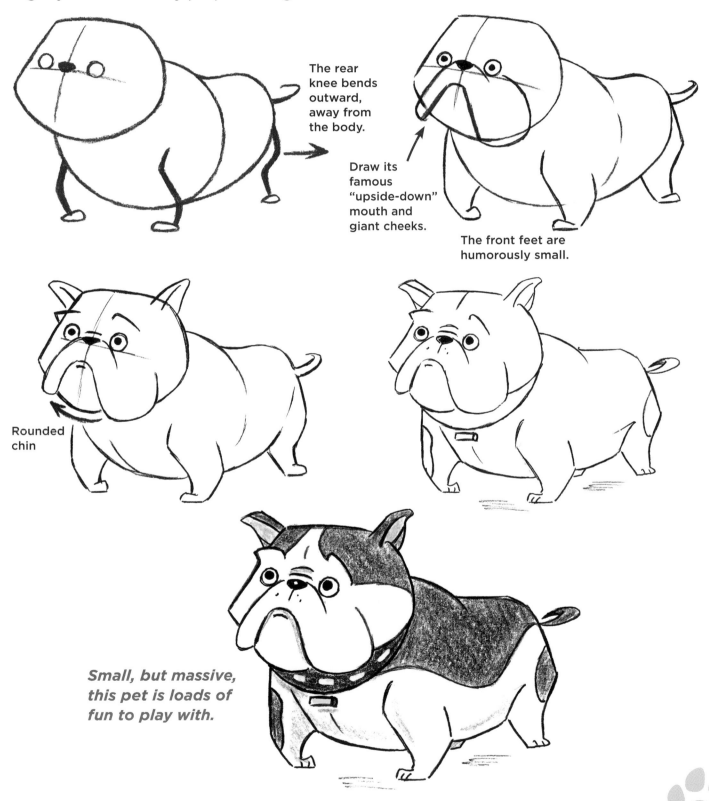

The rear knee bends outward, away from the body.

Draw its famous "upside-down" mouth and giant cheeks.

The front feet are humorously small.

Rounded chin

Small, but massive, this pet is loads of fun to play with.

COCKER SPANIEL

It's hard not to love the cocker spaniel. Its beautiful coat, soulful eyes, rounded head, and wavy ears make it an enduring favorite. Earlier we drew this beloved breed's head. Now we'll take a look at the whole package.

PET TRICK
The cocker has a fit but compact body that looks like an oval when it sits.

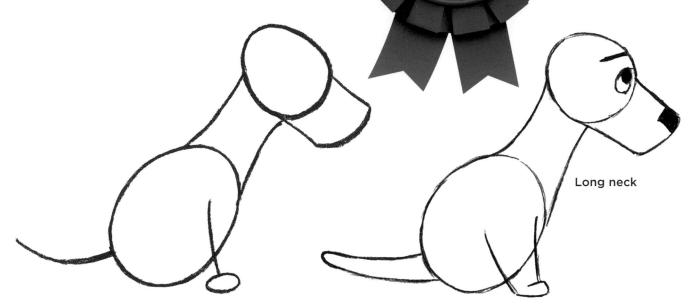

Long neck

At an Angle

Draw the cocker spaniel's body with two strong angles that tilt in opposite directions. Place both paws side by side.

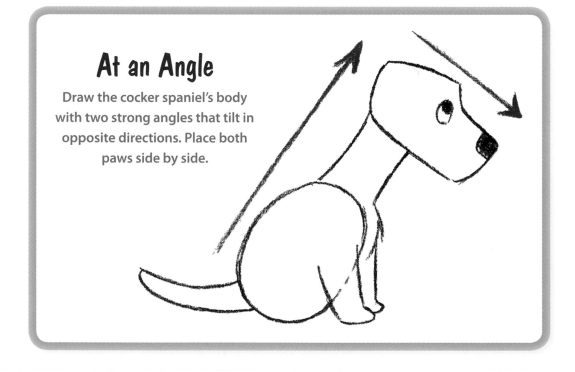

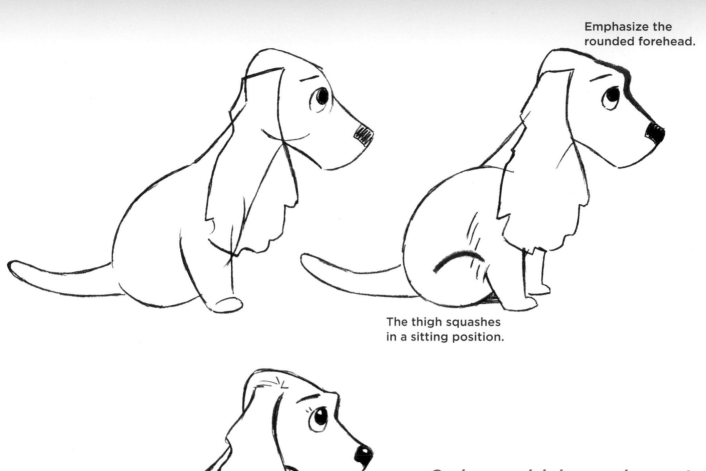

Emphasize the rounded forehead.

The thigh squashes in a sitting position.

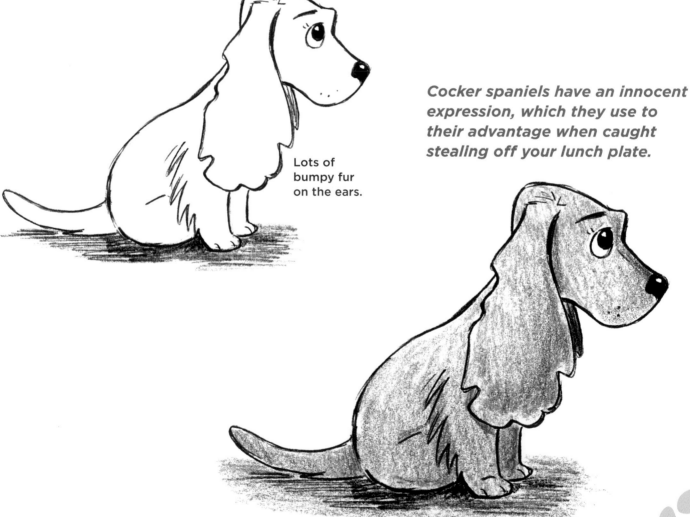

Lots of bumpy fur on the ears.

Cocker spaniels have an innocent expression, which they use to their advantage when caught stealing off your lunch plate.

SALUKI

The saluki is one of the oldest breeds, dating back thousands of years. Although it's a sight hound (hunter), with it's severely tapered body and long, elegant legs, its build is similar to that of a racing dog.

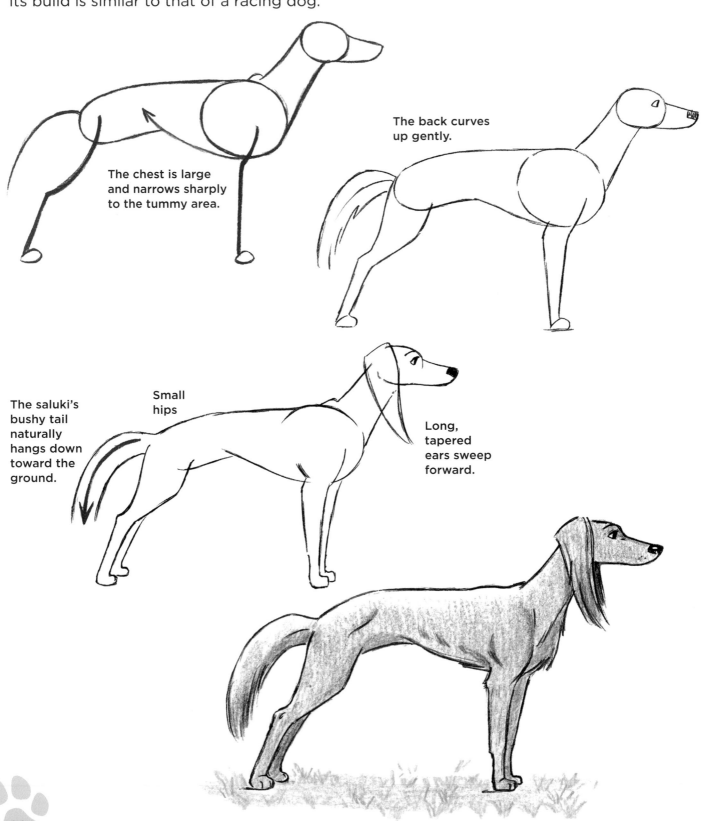

The chest is large and narrows sharply to the tummy area.

The back curves up gently.

The saluki's bushy tail naturally hangs down toward the ground.

Small hips

Long, tapered ears sweep forward.

MALTESE

The Maltese is a show dog in or out of the ring. It may appear pampered, but it loves to romp and play. Its uniquely styled coat is instantly identifiable with the breed. It's not hard to draw, but you need to know a few tricks—and if you follow these steps, you will!

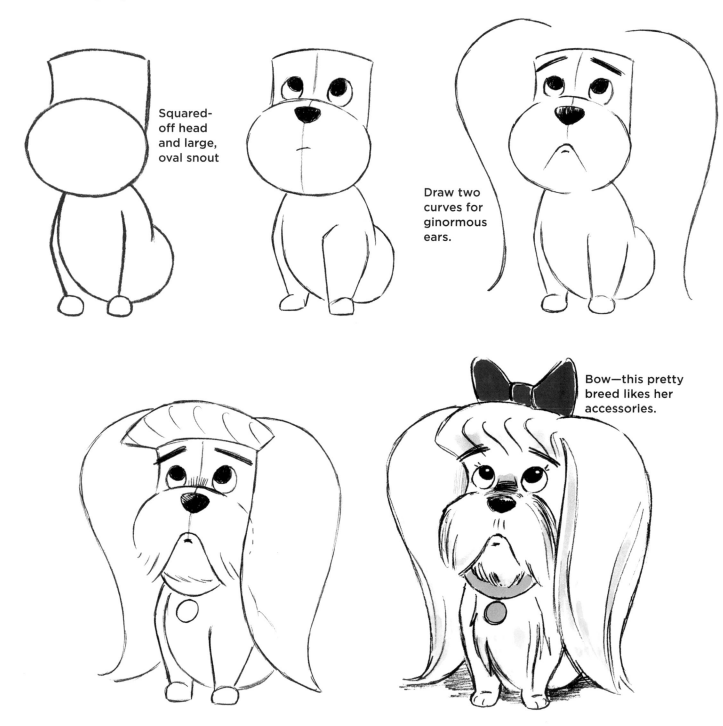

Squared-off head and large, oval snout

Draw two curves for ginormous ears.

Bow—this pretty breed likes her accessories.

STANDARD POODLE

The standard poodle has an agile, athletic build and an intelligent expression. Poodles come in three basic sizes: the standard is the largest, followed by the miniature, and then the toy. This is a popular, well-loved breed.

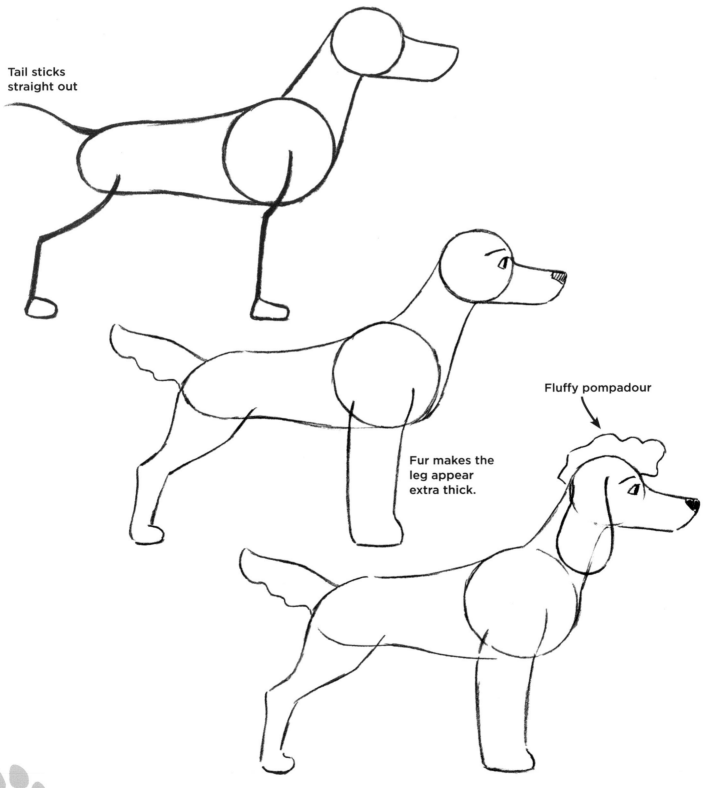

Tail sticks straight out

Fur makes the leg appear extra thick.

Fluffy pompadour

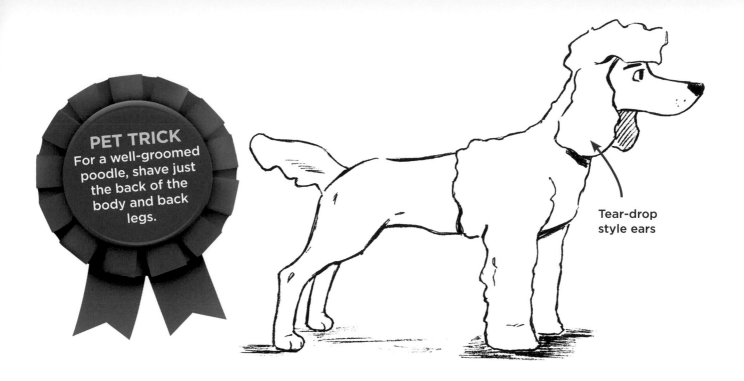

PET TRICK
For a well-groomed poodle, shave just the back of the body and back legs.

Tear-drop style ears

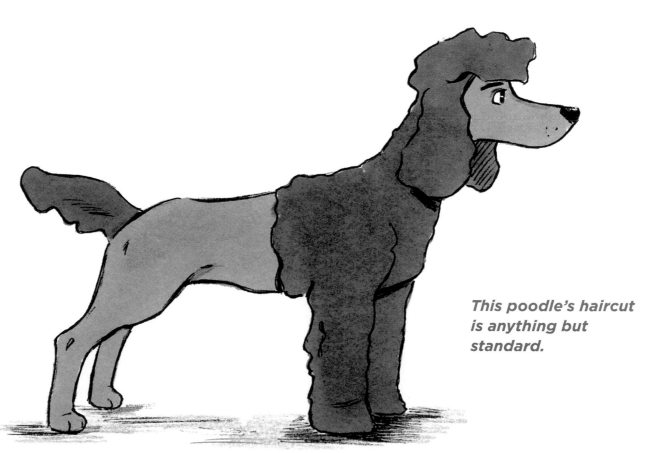

This poodle's haircut is anything but standard.

CORGI

A popular smaller dog is the corgi—although he doesn't know he's small. The corgi is a happy dog that loves its job, which includes chasing squirrels and digging up whatever you just planted.

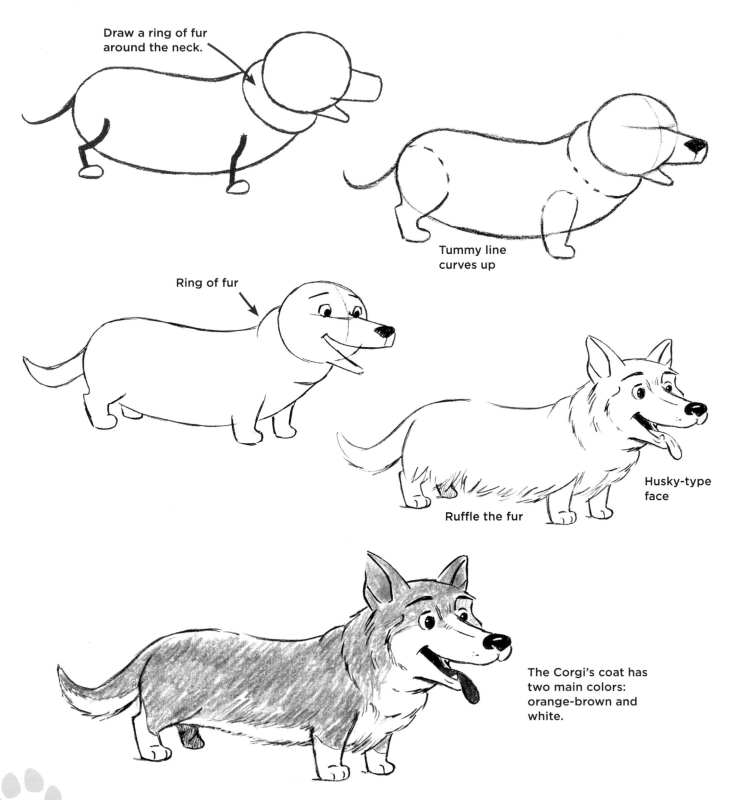

Draw a ring of fur around the neck.

Tummy line curves up

Ring of fur

Ruffle the fur

Husky-type face

The Corgi's coat has two main colors: orange-brown and white.

GERMAN SHORTHAIRED POINTER

This is a handsome, strong dog that has a friendly, attentive demeanor. Weighing up to 70 pounds, it's bigger than many realize. He carries a lot of that weight in his chest.

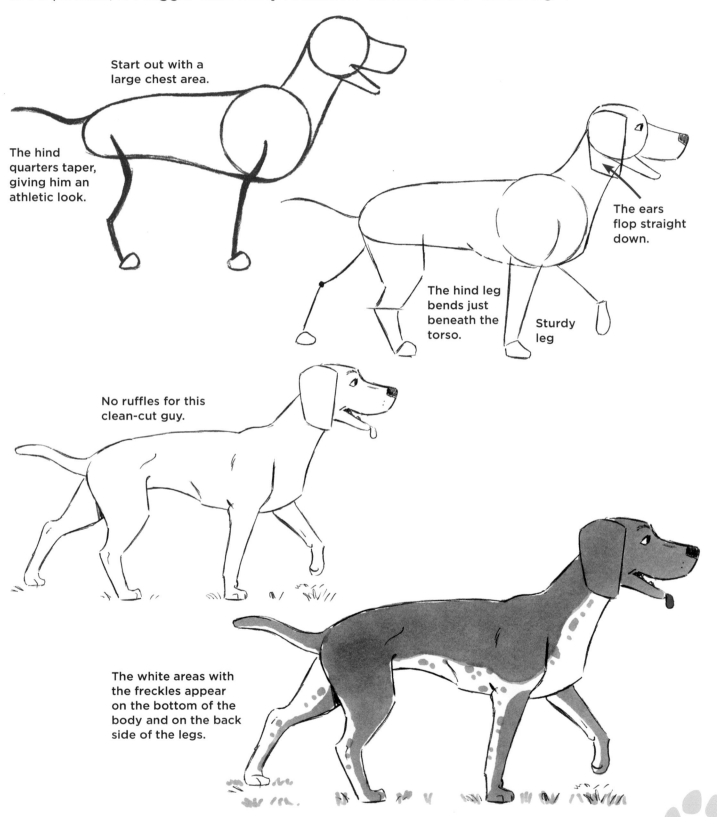

Start out with a large chest area.

The hind quarters taper, giving him an athletic look.

The ears flop straight down.

The hind leg bends just beneath the torso.

Sturdy leg

No ruffles for this clean-cut guy.

The white areas with the freckles appear on the bottom of the body and on the back side of the legs.

CESKY TERRIER

The Cesky terrier has an Eastern European heritage. It possesses a friendly disposition, perhaps even friendlier than some of the more driven terriers. The Cesky's long face has a prominent, wavy hairdo that falls on the snout in front of its eyes.

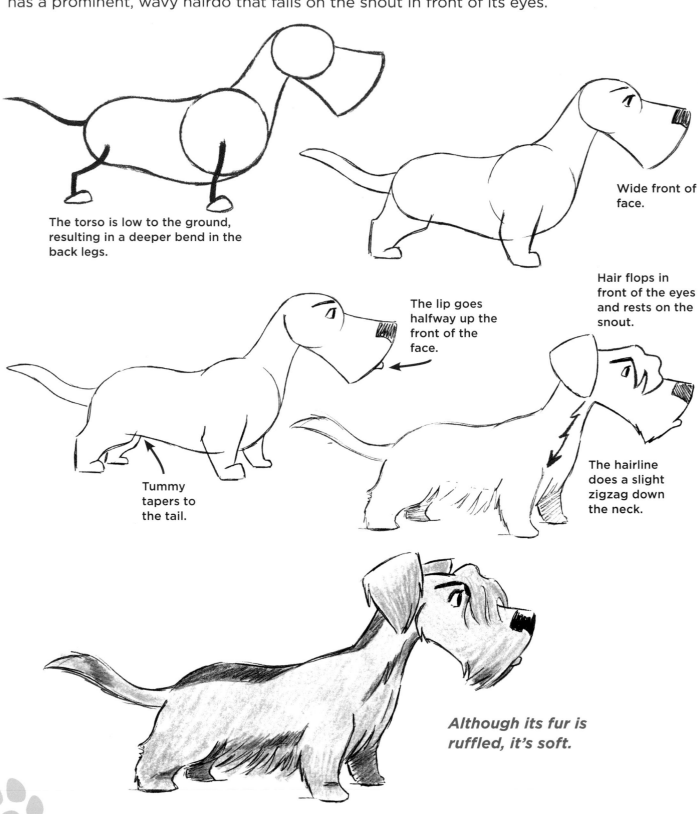

The torso is low to the ground, resulting in a deeper bend in the back legs.

Wide front of face.

The lip goes halfway up the front of the face.

Hair flops in front of the eyes and rests on the snout.

Tummy tapers to the tail.

The hairline does a slight zigzag down the neck.

Although its fur is ruffled, it's soft.

DOODLE DOG

A combination of standard poodle and another breed, doodle dogs are extremely popular. Initially bred as hypoallergenic pets, they have quickly grown in popularity. Two of the most frequent combinations are the golden doodle and the labradoodle.

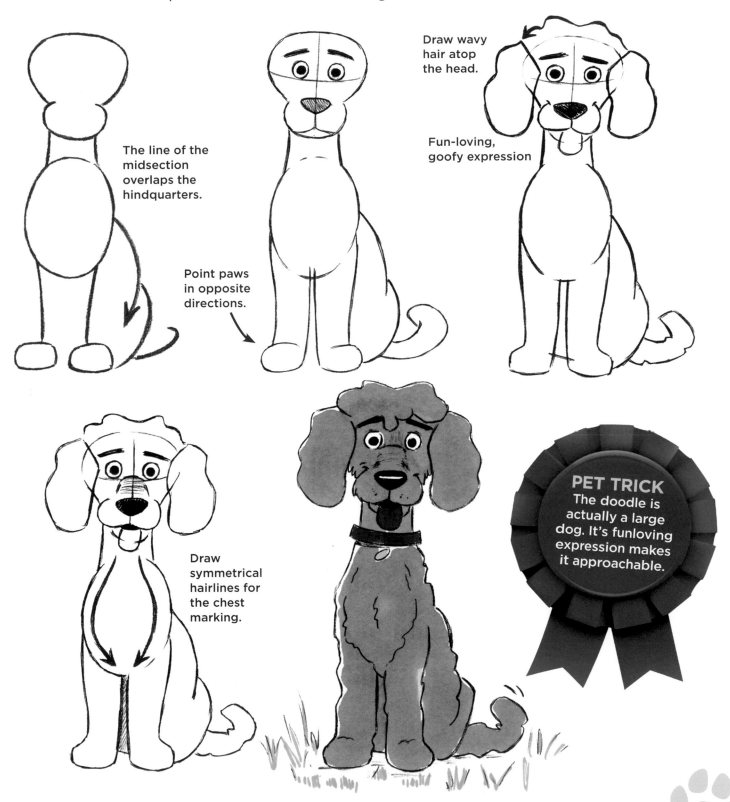

The line of the midsection overlaps the hindquarters.

Point paws in opposite directions.

Draw wavy hair atop the head.

Fun-loving, goofy expression

Draw symmetrical hairlines for the chest marking.

PET TRICK
The doodle is actually a large dog. It's funloving expression makes it approachable.

ENTLEBUCHER SENNENHUND

The Entlebucher sennenhund is a muscular and robust dog, but the smallest of the four Swiss mountain dogs. These include the slightly larger Appenzeller, the large Bernese, and the giant—the Greater Swiss mountain dog. It's highly intelligent. I still haven't beaten it at chess.

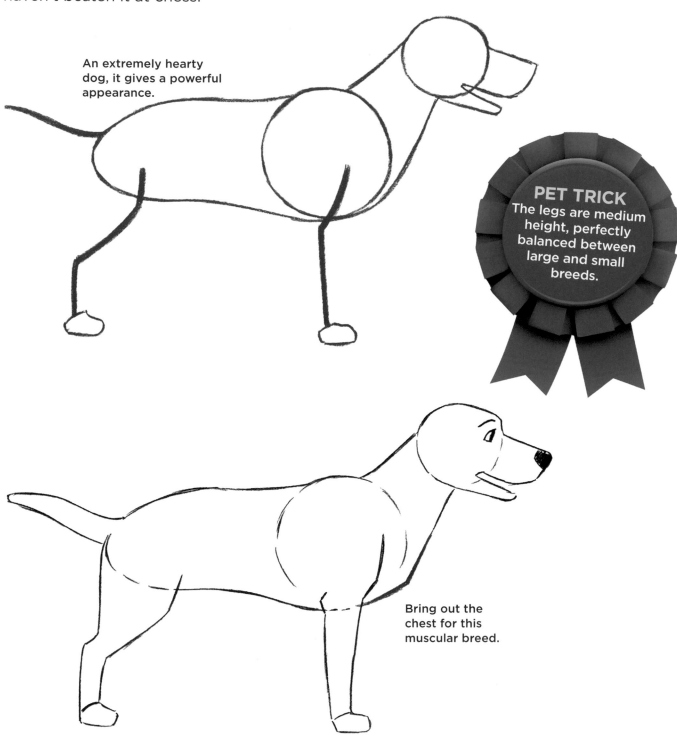

An extremely hearty dog, it gives a powerful appearance.

PET TRICK
The legs are medium height, perfectly balanced between large and small breeds.

Bring out the chest for this muscular breed.

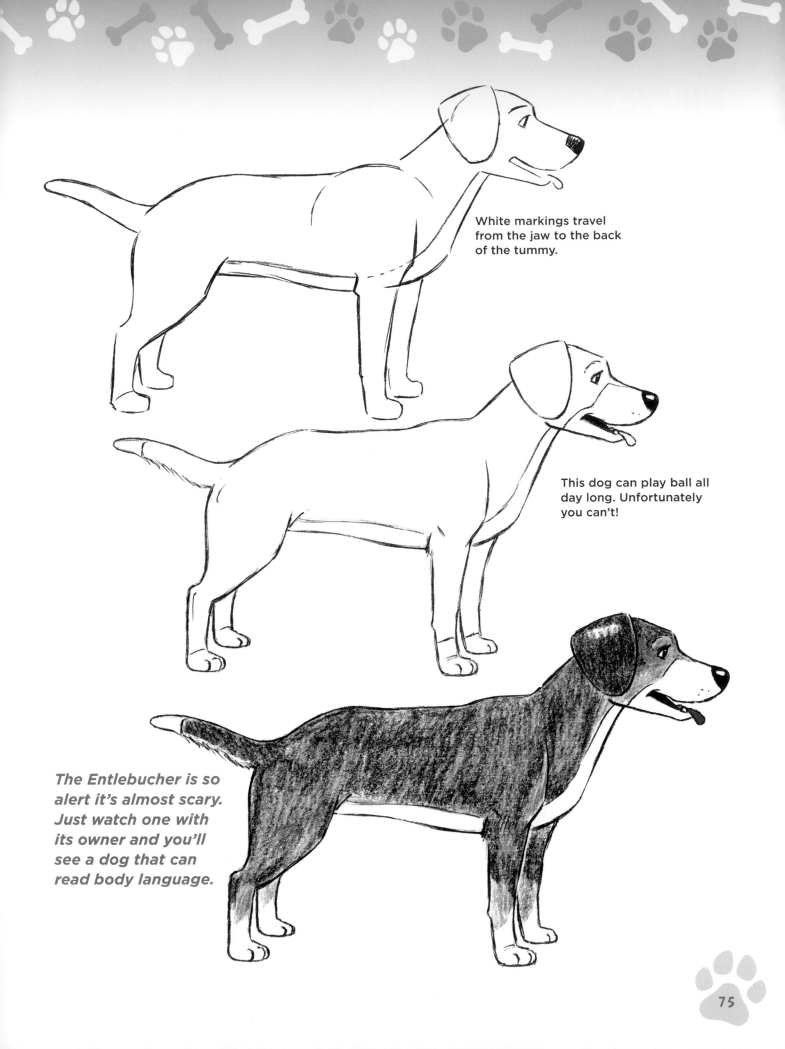

White markings travel from the jaw to the back of the tummy.

This dog can play ball all day long. Unfortunately you can't!

The Entlebucher is so alert it's almost scary. Just watch one with its owner and you'll see a dog that can read body language.

WHIPPET

The whippet is an elegant dog that is built for speed. Most of its weight is distributed to its powerful chest and thighs. The rest of the frame remains light, which is why it can run so fast.

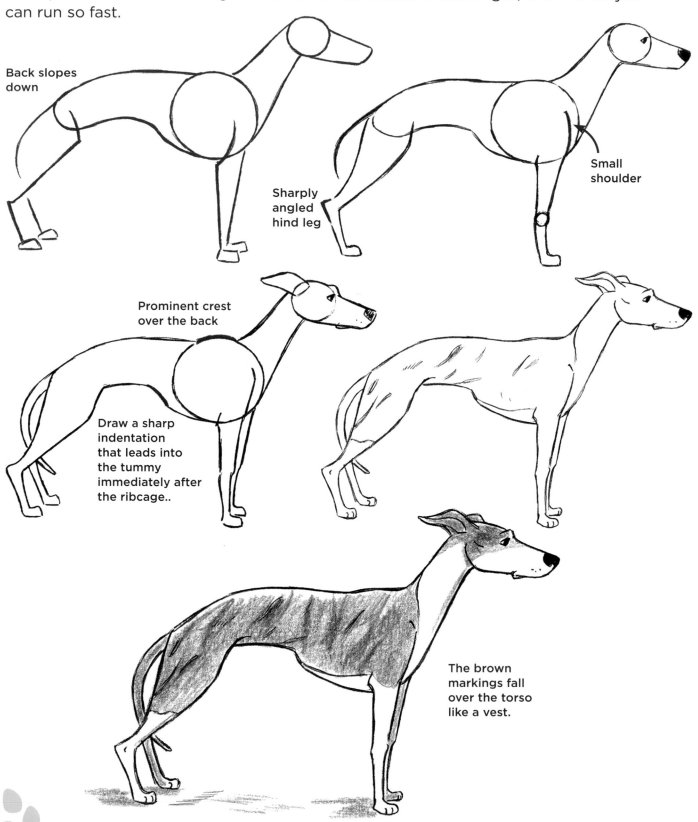

Back slopes down

Sharply angled hind leg

Small shoulder

Prominent crest over the back

Draw a sharp indentation that leads into the tummy immediately after the ribcage..

The brown markings fall over the torso like a vest.

CHESAPEAKE BAY RETRIEVER

The Chesapeake Bay retriever is a powerful dog. It can play fetch with a tree trunk. Its rough, short coat has a few curls, but it's not really a curly-coated dog. It has a cheerful, though watchful, expression.

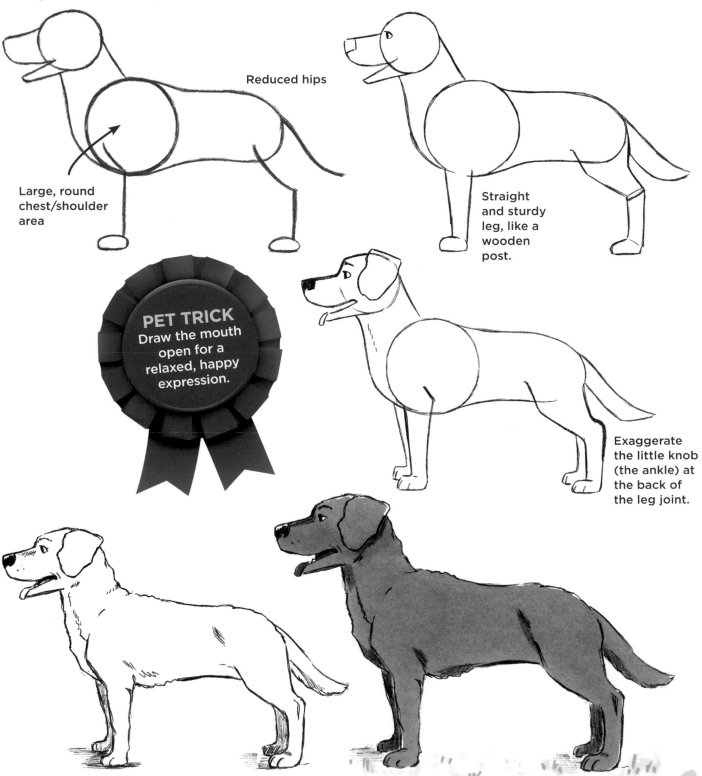

Reduced hips

Large, round chest/shoulder area

Straight and sturdy leg, like a wooden post.

PET TRICK
Draw the mouth open for a relaxed, happy expression.

Exaggerate the little knob (the ankle) at the back of the leg joint.

BORDER TERRIER

The border terrier is a small dog, but a superior hunter nevertheless, as well as an active family pet. It has a rugged, no nonsense appearance. Most notable are its ruffled muzzle, forward-folded ears, and grizzled coat.

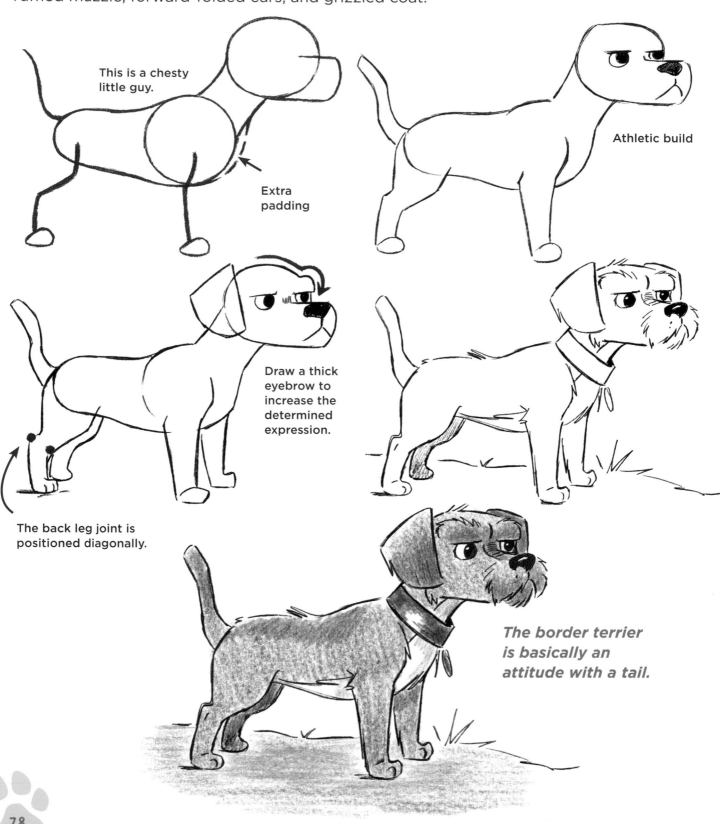

This is a chesty little guy.

Extra padding

Athletic build

Draw a thick eyebrow to increase the determined expression.

The back leg joint is positioned diagonally.

The border terrier is basically an attitude with a tail.

FRENCH BULLDOG

Somewhat similar to the pug, the French bulldog has uniquely tall, upright ears. Like the pug, it has a darkened muzzle, but doesn't have a profusion of wrinkles. It has an inquisitive expression and an athletic body.

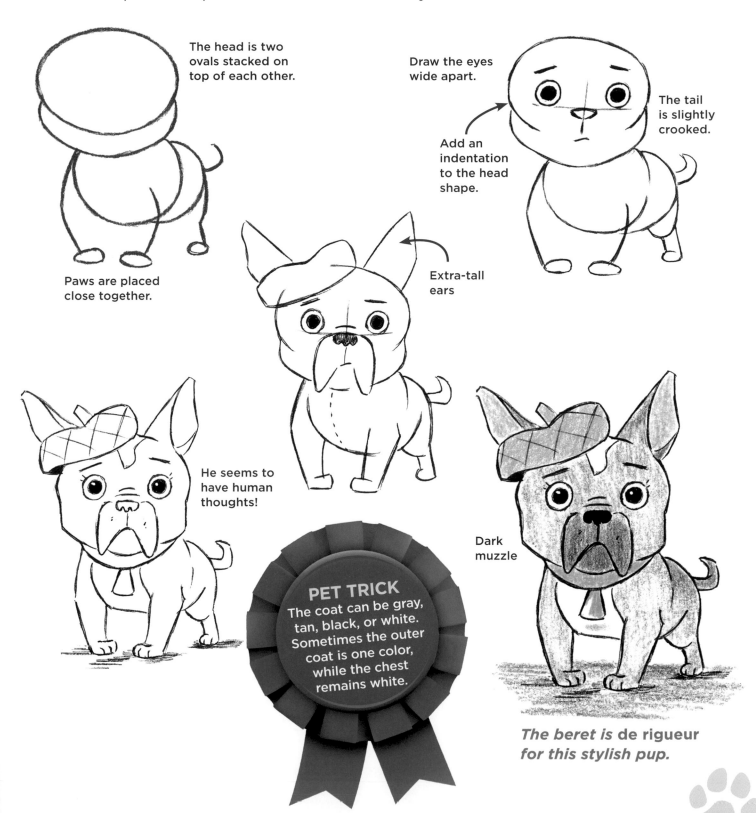

The head is two ovals stacked on top of each other.

Paws are placed close together.

Draw the eyes wide apart.

Add an indentation to the head shape.

The tail is slightly crooked.

Extra-tall ears

He seems to have human thoughts!

PET TRICK
The coat can be gray, tan, black, or white. Sometimes the outer coat is one color, while the chest remains white.

Dark muzzle

The beret is de rigueur for this stylish pup.

MORE DOGGIE POSES

Let's draw some engaging dogs in simple poses. Just a turn of the head or a movement of the paw is all it takes. We'll still start with a simple template.

Father and Son

Even the most energetic dog can turn into a patient playmate around a puppy. Here, we have two dogs of the same breed—a father and son. Notice how the dad bends down low to accommodate the puppy.

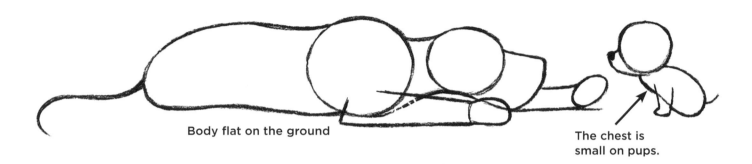

Body flat on the ground

The chest is small on pups.

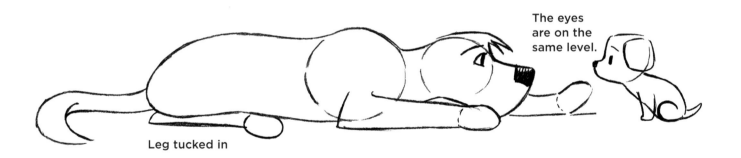

The eyes are on the same level.

Leg tucked in

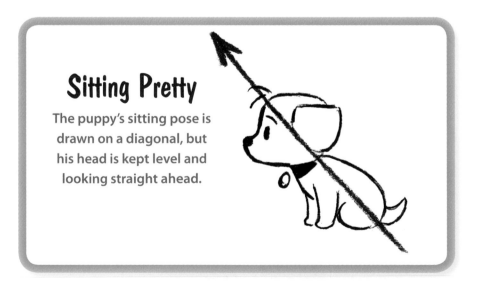

Sitting Pretty

The puppy's sitting pose is drawn on a diagonal, but his head is kept level and looking straight ahead.

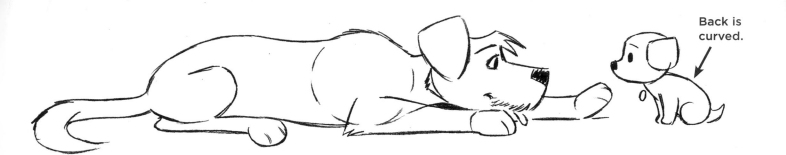

Back is curved.

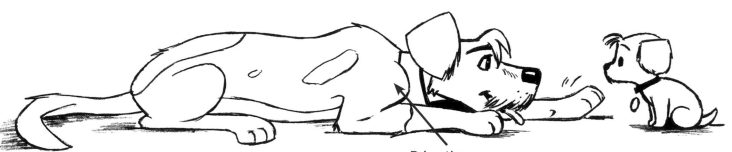

Bring the shoulder forward.

PET TRICK
Give both dogs the same color scheme so they appear related, but leave the spots off the pup.

The puppy is thinking, "Dad, teach me where they keep the treats!"

Playtime!

This dog is trying to act so charming that its owner will be forced to put down whatever he's doing and toss the ball instead. All is fair in love and catch.

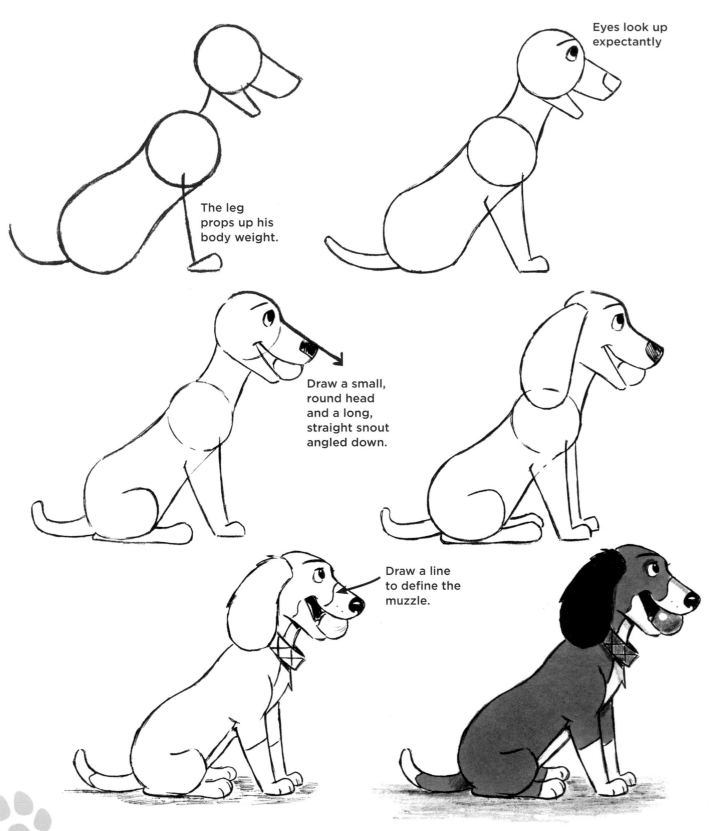

The leg props up his body weight.

Eyes look up expectantly

Draw a small, round head and a long, straight snout angled down.

Draw a line to define the muzzle.

Now That's Talent

I've never been able to juggle, so how did this guy figure it out? This cute pose is created by drawing the head off the ground, but keeping the back flat.

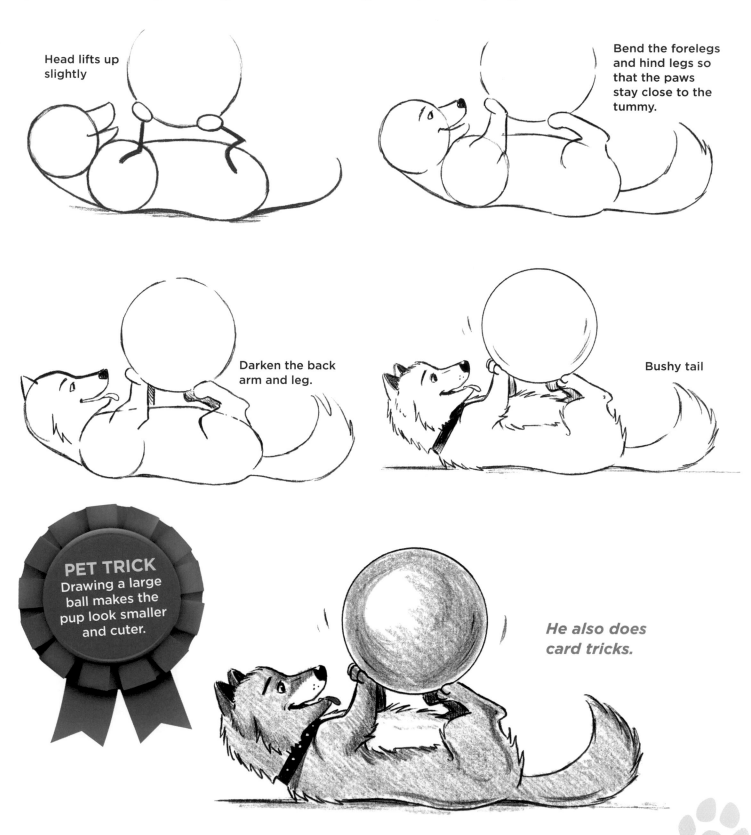

Head lifts up slightly

Bend the forelegs and hind legs so that the paws stay close to the tummy.

Darken the back arm and leg.

Bushy tail

PET TRICK
Drawing a large ball makes the pup look smaller and cuter.

He also does card tricks.

Now What?

Either this pup truly can't figure out how to retrieve the ball, or he's trying to lure his owner into a game of catch. I've drawn this mixed breed by using common attributes of dogs this size, including a scruffy forehead and mouth, long ears, and a compact body.

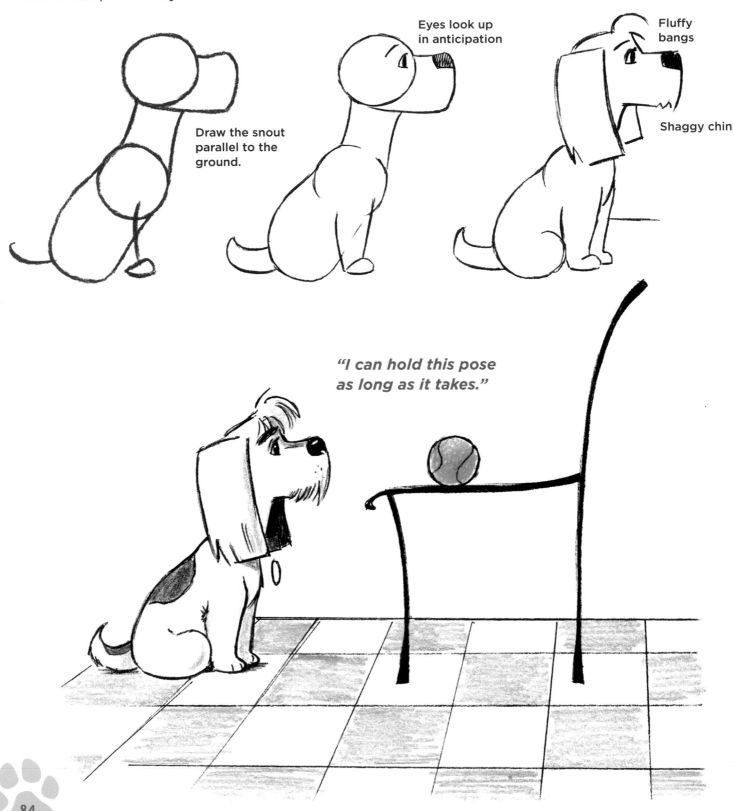

Draw the snout parallel to the ground.

Eyes look up in anticipation

Fluffy bangs

Shaggy chin

"I can hold this pose as long as it takes."

Pose for the Camera

We've been drawing side views in this section. Now, we'll break down the ¾ view. It's a partial side view that cheats toward the front.

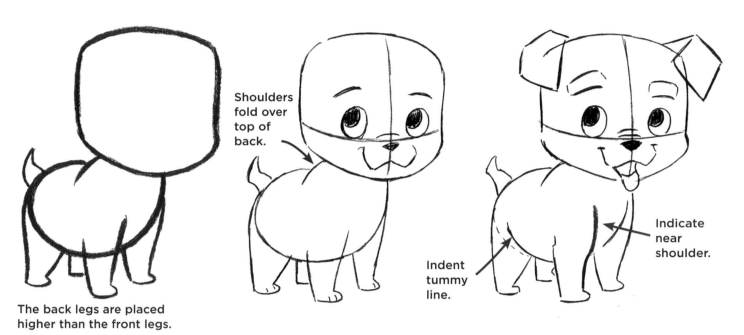

Shoulders fold over top of back.

Indent tummy line.

Indicate near shoulder.

The back legs are placed higher than the front legs.

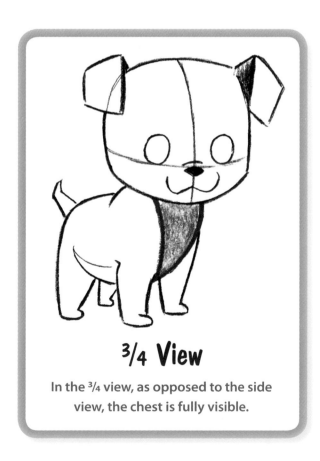

¾ View

In the ¾ view, as opposed to the side view, the chest is fully visible.

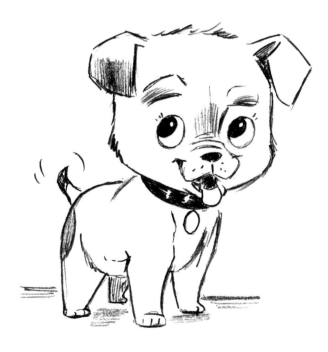

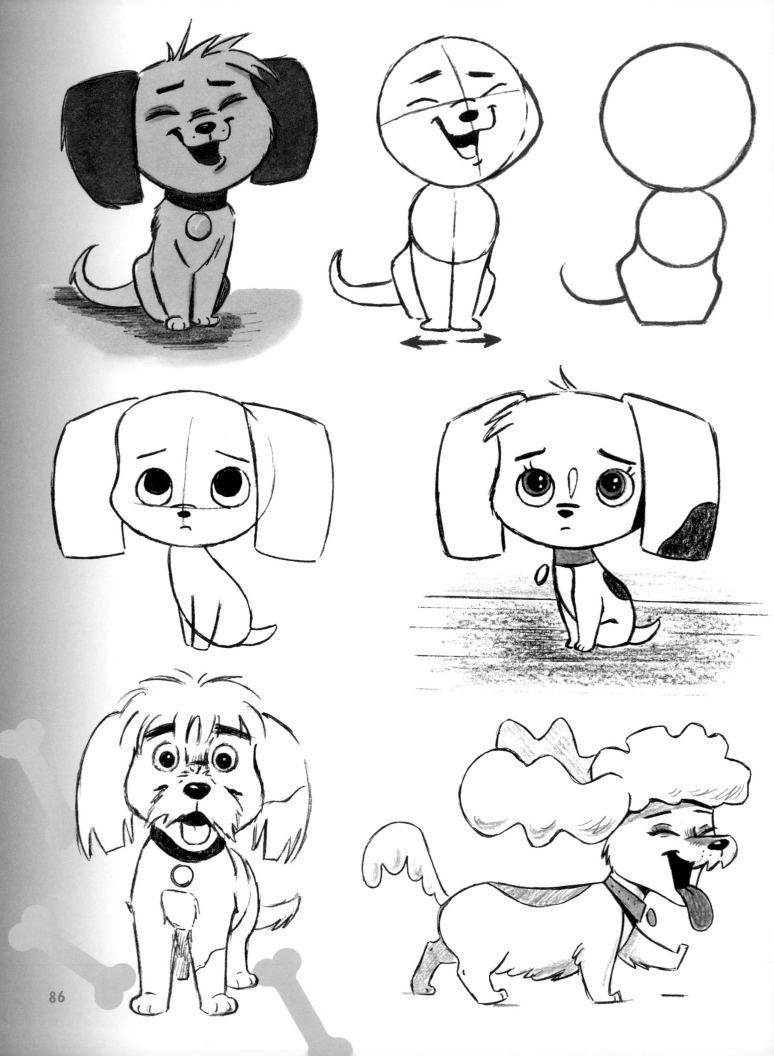

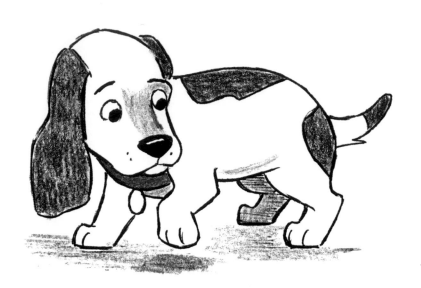

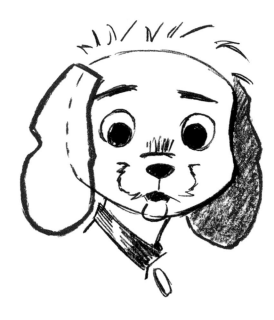

DRAWING DOGS
PUPPY POWER!

And now the moment you've been waiting for: a whole chapter devoted to younger dogs and puppies. Young dogs are drawn with simplified shapes. The eyes are big, round, and oversized, and the nose and mouth are small. The ears are often way too big. But you don't have to follow the guidelines perfectly. Variations can also work.

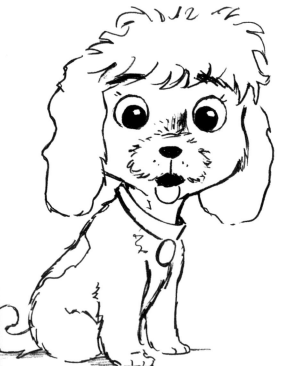

CAVALIER KING CHARLES SPANIEL PUPPY

The Cavalier King Charles spaniel ranks high on the list of popular dog breeds. It has a regal appearance with beautiful colors and perfect markings. But it's a down-to-earth puppy that loves its family and has a range of human-like expressions.

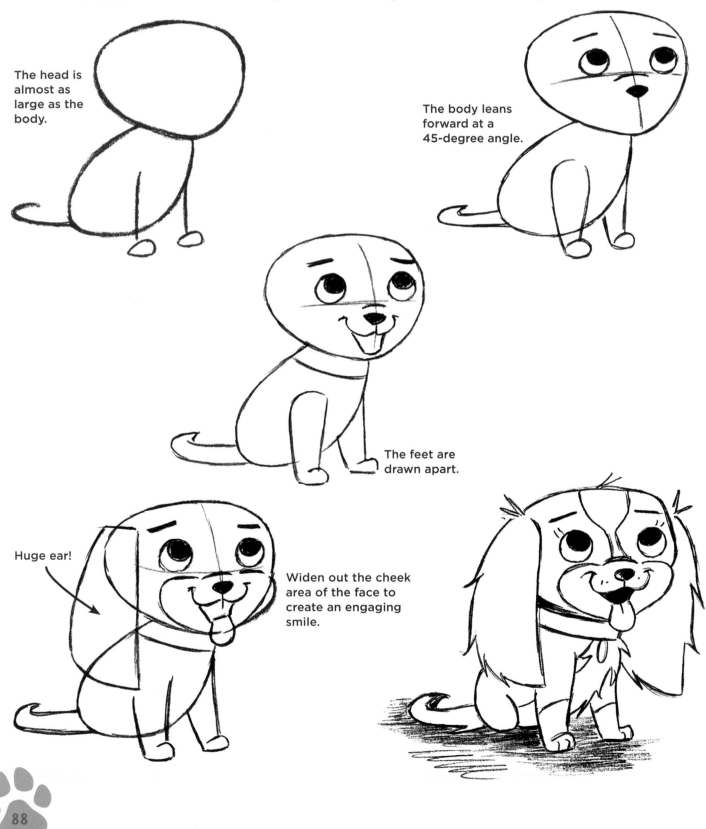

The head is almost as large as the body.

The body leans forward at a 45-degree angle.

The feet are drawn apart.

Huge ear!

Widen out the cheek area of the face to create an engaging smile.

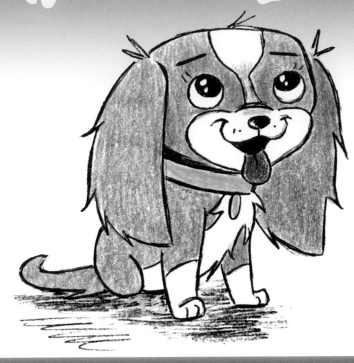

How do they fit so much joy into such a little package!

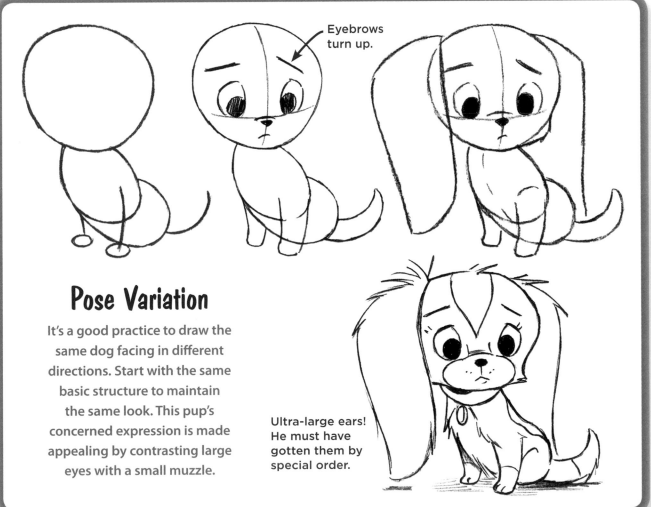

Eyebrows turn up.

Pose Variation

It's a good practice to draw the same dog facing in different directions. Start with the same basic structure to maintain the same look. This pup's concerned expression is made appealing by contrasting large eyes with a small muzzle.

Ultra-large ears! He must have gotten them by special order.

BABY BULLDOG

With a head that is oversized and a constantly quizzical "Why am I here?" expression, baby bulldogs require immediate hugging. Some have more wrinkles around the muzzle. You can decide how many to use when you draw yours.

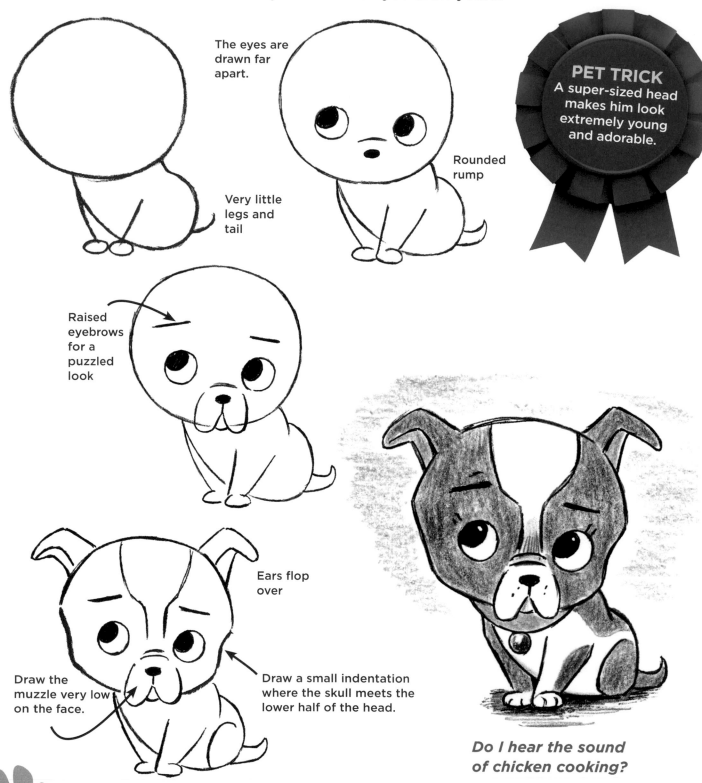

The eyes are drawn far apart.

Very little legs and tail

Rounded rump

PET TRICK
A super-sized head makes him look extremely young and adorable.

Raised eyebrows for a puzzled look

Ears flop over

Draw the muzzle very low on the face.

Draw a small indentation where the skull meets the lower half of the head.

Do I hear the sound of chicken cooking?

DOODLE PUPPY

With their appealing look, doodle puppies could practically trademark the word "charming." Fortunately for us pet artists, they are built on simple, round shapes.

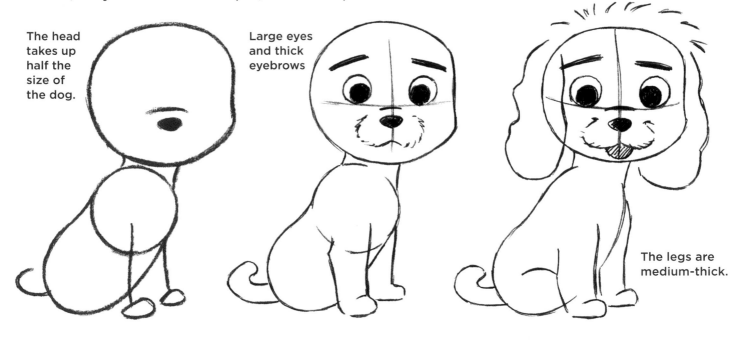

The head takes up half the size of the dog.

Large eyes and thick eyebrows

The hair on top of the head is fluffy.

The legs are medium-thick.

Layering Tip

Draw one ear in front of the head and one ear behind it.

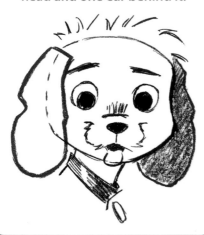

PET TRICK
Give the ears a wavy, almost bumpy coat to indicate fur.

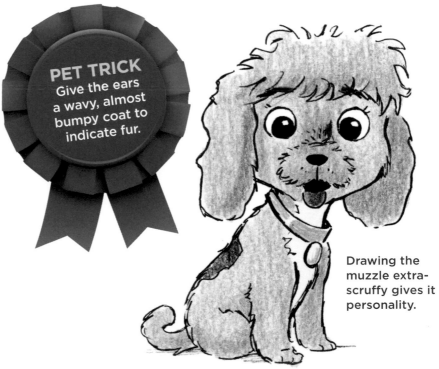

Drawing the muzzle extra-scruffy gives it personality.

Doodle puppies usually have an eager "What are we doing next?" expression. Better find that Frisbee.

FOXHOUND PUPPY

The foxhound puppy, like its adult counterpart we drew earlier, is a well-proportioned dog. But because it's still a pup, it's going to have a little extra padding, mainly on its tummy.

The body is shaped like an oval.

Softly curved back

Rounded paws

PET TRICK
Puppies often have thicker legs and paws that will thin out as they get older.

Oversized ears

Clear markings

Add a shadow under the raised paw.

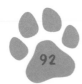

CONCERNED PUPPY

You know this look. It happens when a puppy has his heart set on going for a walk. If he starts to blink those big eyes, it's all over. We humans are so predictable.

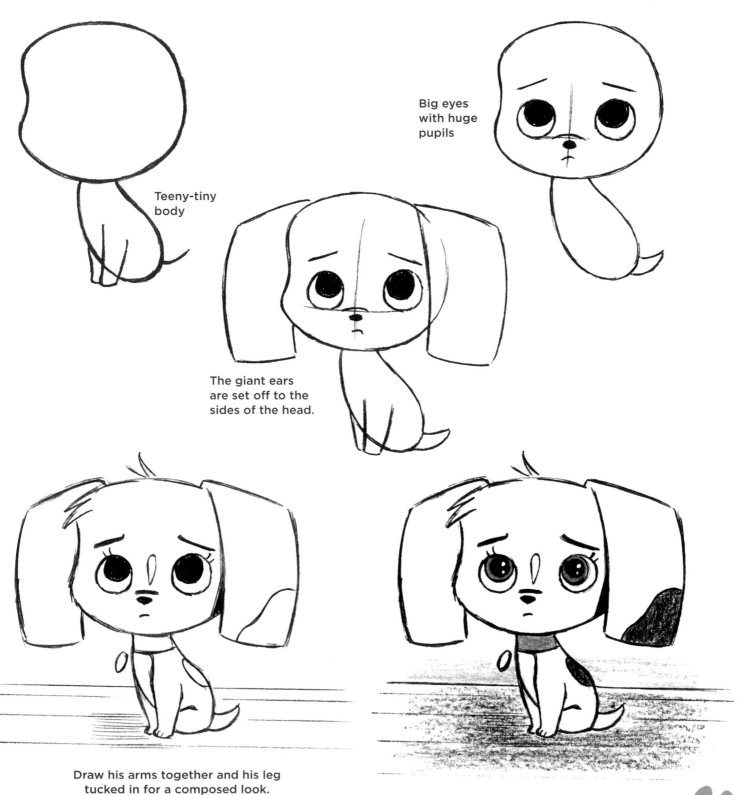

Big eyes with huge pupils

Teeny-tiny body

The giant ears are set off to the sides of the head.

Draw his arms together and his leg tucked in for a composed look.

LAUGHING PUPPY

As artists, we can take a few liberties in order to capture the expression we want. In this case, I wanted to create a super-happy puppy. (Yes, they really do smile!) So I pushed the expression a little further to create a laugh.

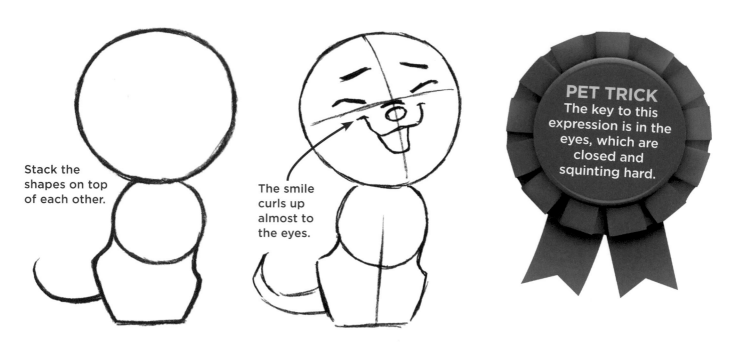

Stack the shapes on top of each other.

The smile curls up almost to the eyes.

PET TRICK
The key to this expression is in the eyes, which are closed and squinting hard.

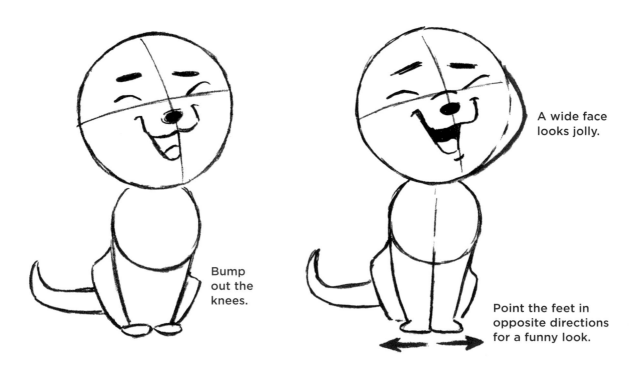

Bump out the knees.

A wide face looks jolly.

Point the feet in opposite directions for a funny look.

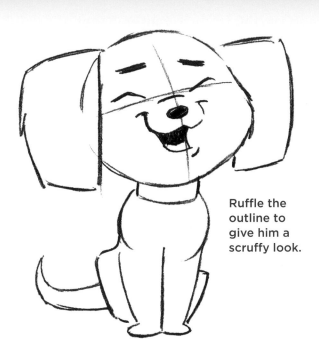

Ruffle the outline to give him a scruffy look.

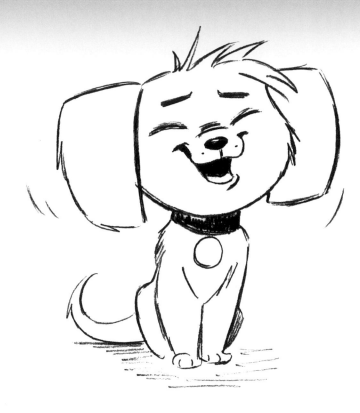

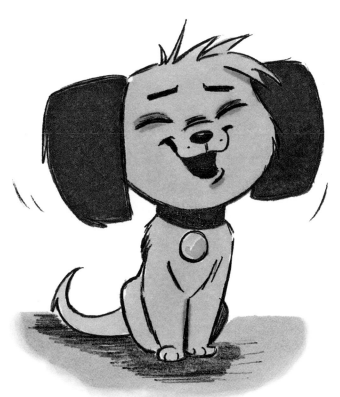

"Humans, you're such an amusing species!"

Color Me Cute

Try drawing the same pup in different colors.

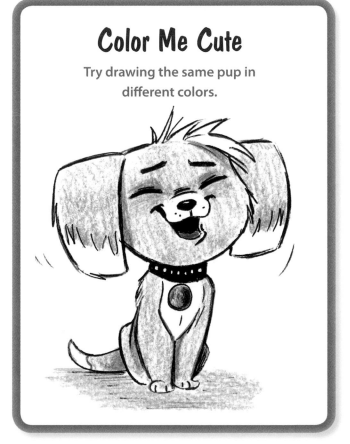

MIXED-BREED PUPPY

One of our relatives recently adopted a mixed breed puppy from a shelter. What a great dog. An instant companion for life. When I draw mixed breeds, I like to draw them slightly untidy, but with a sparkling expression that shines through.

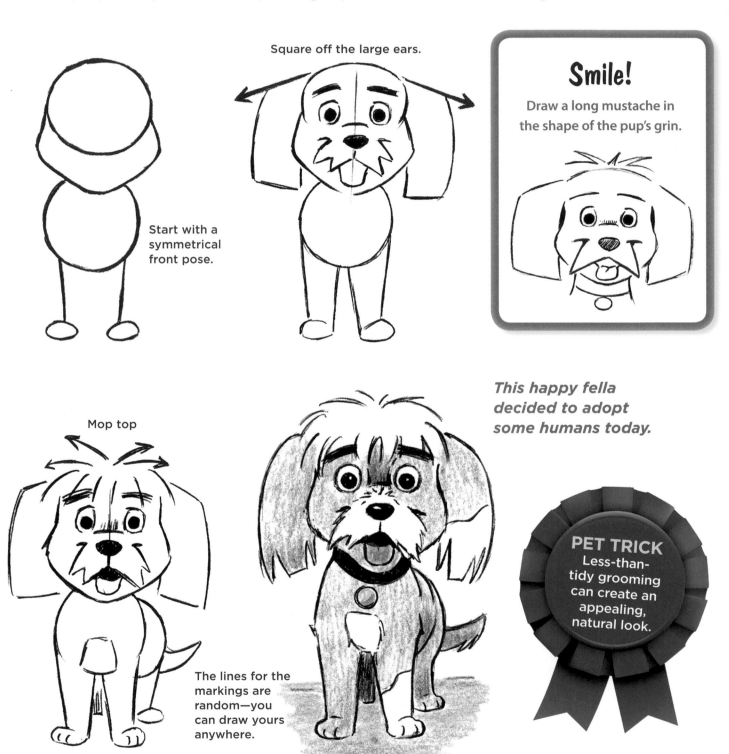

Start with a symmetrical front pose.

Square off the large ears.

Smile!
Draw a long mustache in the shape of the pup's grin.

Mop top

The lines for the markings are random—you can draw yours anywhere.

This happy fella decided to adopt some humans today.

PET TRICK
Less-than-tidy grooming can create an appealing, natural look.

DANDIE DINMONT TERRIER

This energetic little guy is a frolicking, fun-loving, and affectionate pet. Although the Dandie Dinmont is a rare breed, it's been around for over three centuries. People friendly and outgoing, it makes a great subject for expressive action poses.

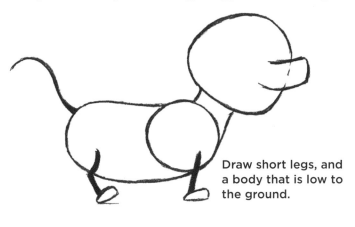

Draw short legs, and a body that is low to the ground.

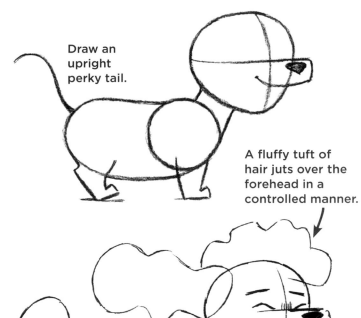

Draw an upright perky tail.

A fluffy tuft of hair juts over the forehead in a controlled manner.

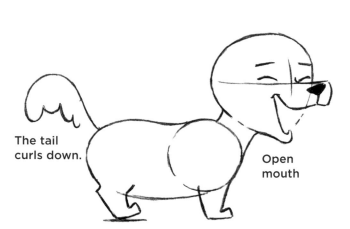

The tail curls down.

Open mouth

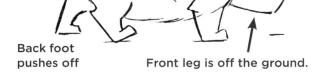

Back foot pushes off

Front leg is off the ground.

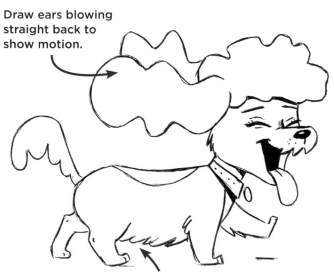

Draw ears blowing straight back to show motion.

Draw ruffles along the tummy line..

He's got two tickets to the dog show.

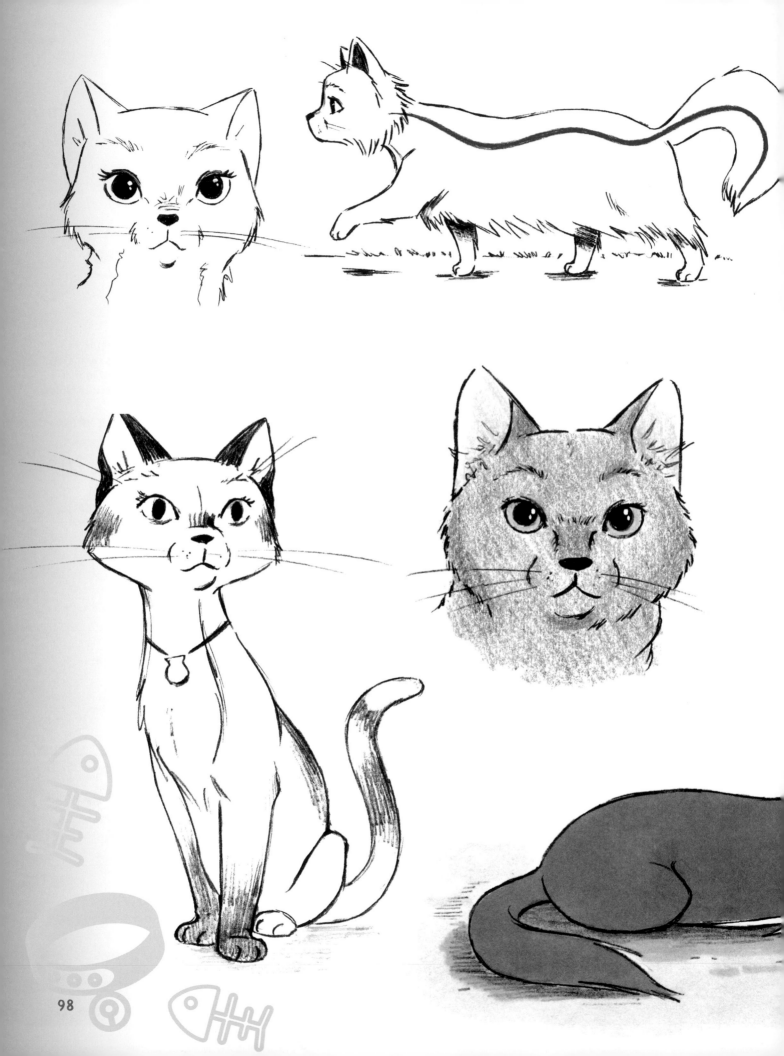

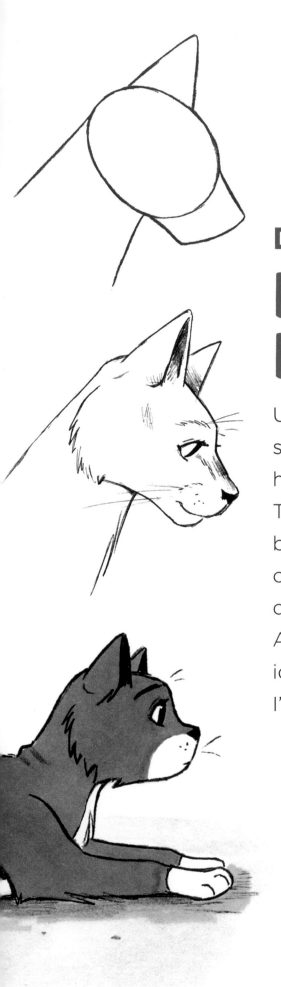

DRAWING CATS
FABULOUS FELINES

Unlike dogs, which can vary in size and shape to an amazing degree, most cats have similar builds and proportions. This chapter will point out the smaller but still important differences in their coats, eyes, ears, and other features that distinguish different breeds and types. And to save you the detective work of identifying each diference by yourself. I'll point them out, step by step.

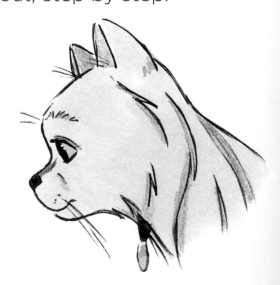

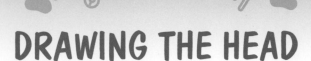

DRAWING THE HEAD

Let's quickly look at the notable characteristics of a cat's head. The first is that the snout is short. The pads of the upper lips are distinct shapes, which are prominent. The ears are large, relative to the size of the head. Can't remember all those tips? You don't need to! I'll point them out as we come to them.

Short-Haired Cats

A short-haired cat begins with a basic construction that doesn't include the fur. Although there are a few ruffles, the coat adheres to the outline of the cat's head.

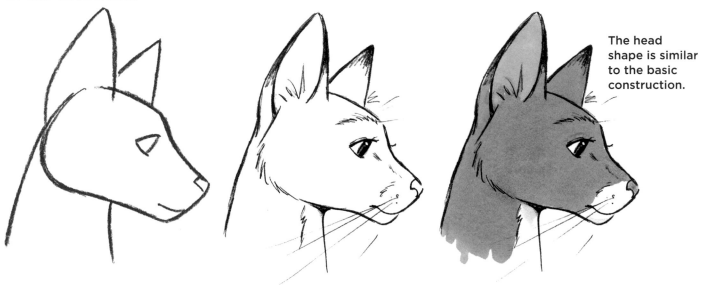

The head shape is similar to the basic construction.

Long-Haired Cats

Long-haired cats are a different story. Their profuse coat changes the look of the head. Therefore, we incorporate it into the basic shape.

Cheek ruffles are treated as part of the face shape.

The underlying head shape is overtaken by the full coat.

The Head in Profile

One of the more prominent differences between the head shapes of different cats is the length of the forehead.

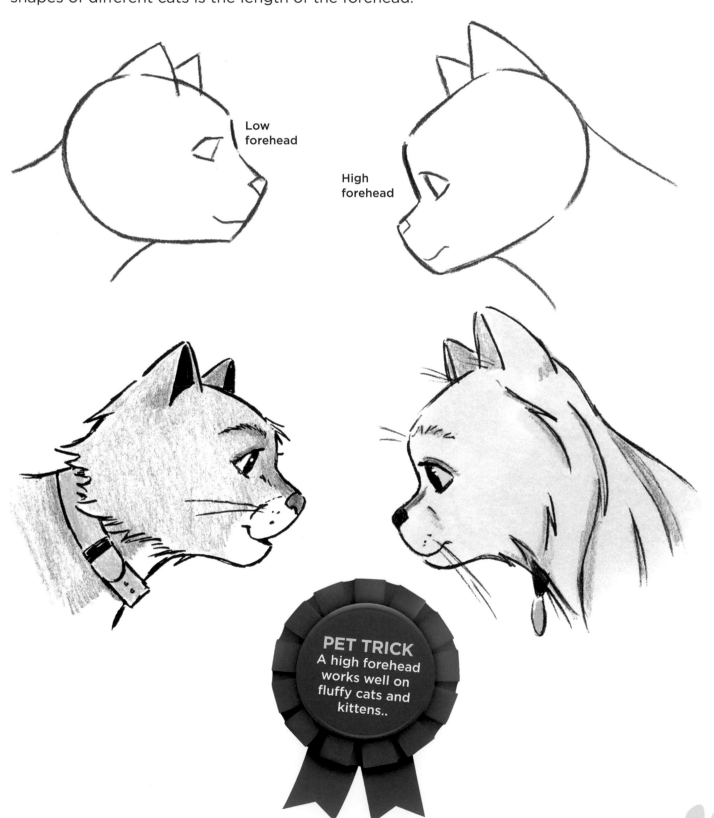

Low forehead

High forehead

PET TRICK
A high forehead works well on fluffy cats and kittens..

CAT EYES

The most common colors for cats' eyes are blue, green, and yellow. The pupils are always black. The eyebrows can be indicated as a rough ridge with or without a few whiskers emanating from it.

The eyes tilt up slightly.

The eyes are tapered at the ends.

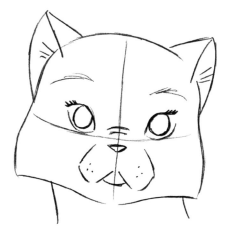

Add short eyelashes.

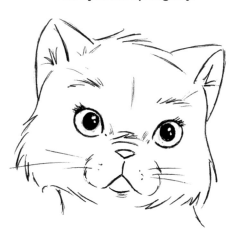

A few shines on the pupils add brilliance.

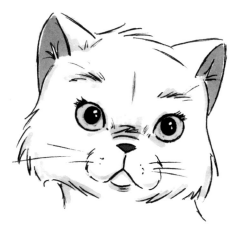

The contrast of black pupils against colored irises is striking.

The Eyes Have It

Just changing the eye color is an easy way to create a different look. Green and blue are less common eye colors for cats.

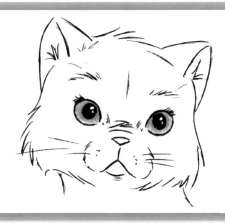

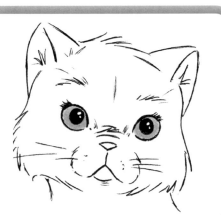

PERSIAN

The Persian is famous for its fluffiness. But as artists, we think about its structure, too. Its head has a distinct shape with an unusually short muzzle.

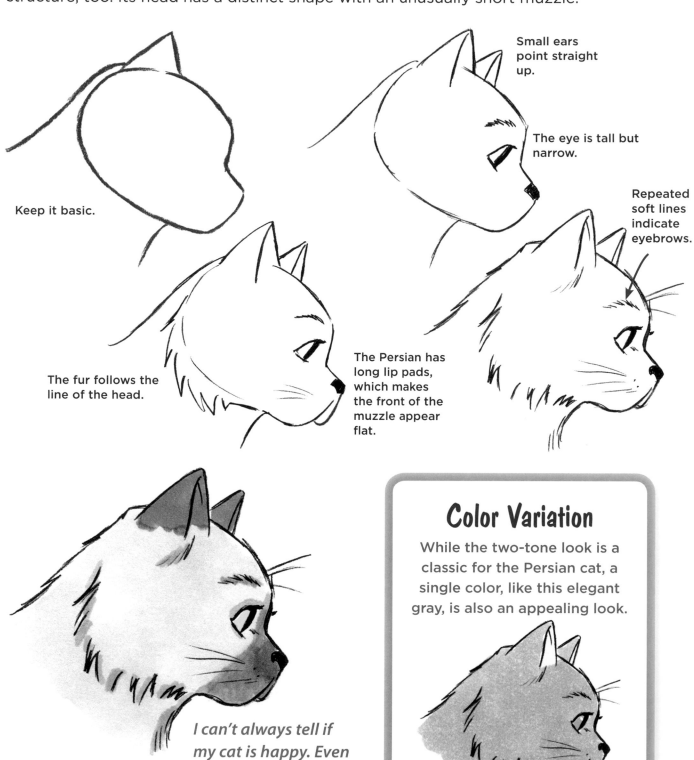

Keep it basic.

Small ears point straight up.

The eye is tall but narrow.

Repeated soft lines indicate eyebrows.

The fur follows the line of the head.

The Persian has long lip pads, which makes the front of the muzzle appear flat.

I can't always tell if my cat is happy. Even when I ask him, he's noncomittal.

Color Variation

While the two-tone look is a classic for the Persian cat, a single color, like this elegant gray, is also an appealing look.

KITTEN EYES

Owing to the proportions of young animals, kitten eyes are drawn close to the nose with extra-large pupils. On kittens, the eyes appear low on the head, whereas they are placed higher on adult cats.

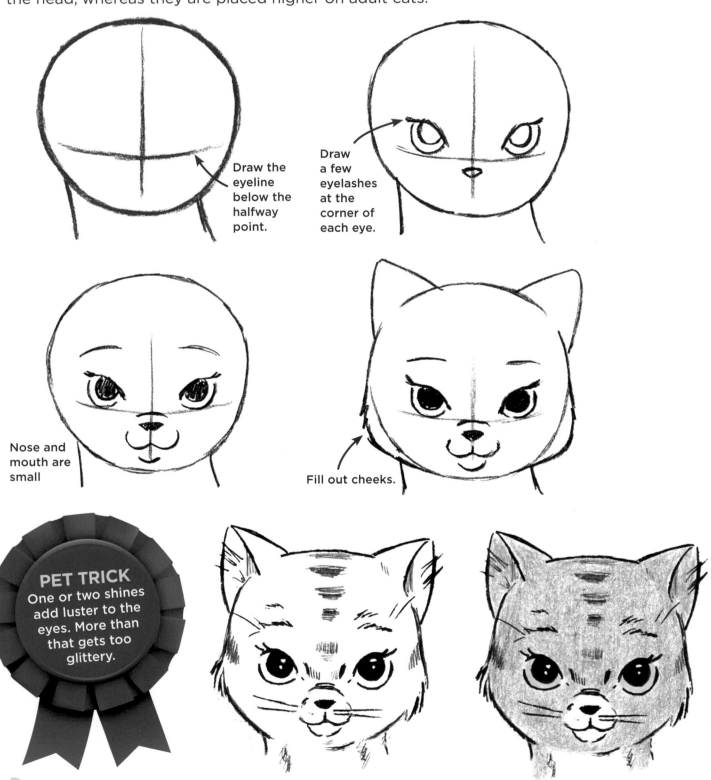

Draw the eyeline below the halfway point.

Draw a few eyelashes at the corner of each eye.

Nose and mouth are small

Fill out cheeks.

PET TRICK
One or two shines add luster to the eyes. More than that gets too glittery.

EARS

The outer flap of the ears is long, while the inner side of the ear is short.

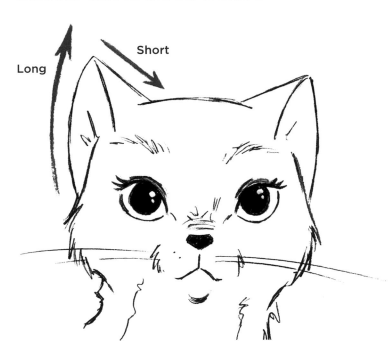

Long

Short

From Ear to Ear

The most common ear type is drawn with a smooth outer flap. A popular variation has a wiggly flap.

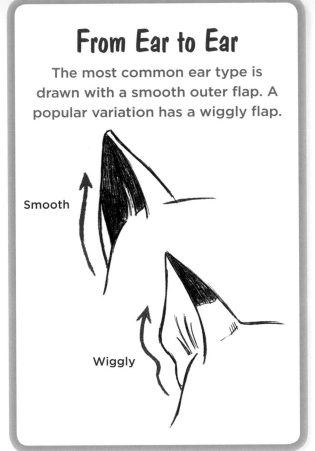

Smooth

Wiggly

MOUTH

The muzzle is drawn in the shape of a kidney bean tilted on its side.

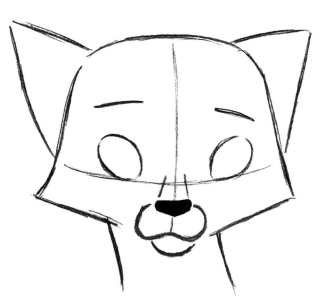

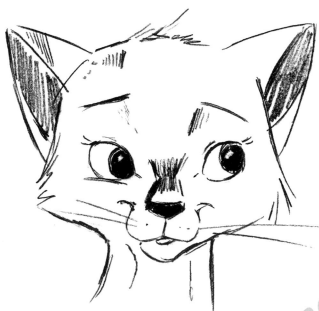

SO SWEET

The mouth of a kitten is small, even delicate. Therefore, we place the emphasis on the largest feature of the face—the eyes.

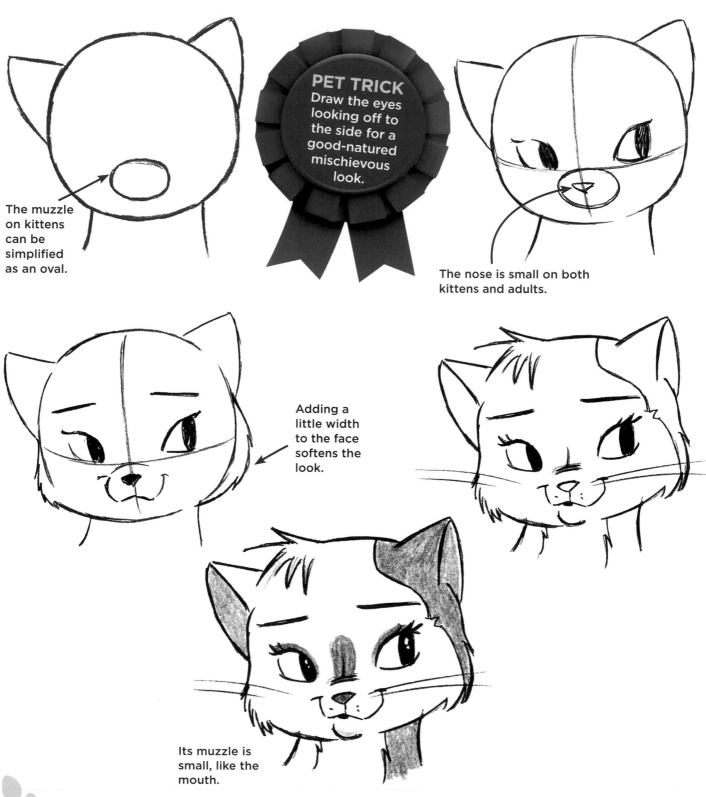

The muzzle on kittens can be simplified as an oval.

PET TRICK
Draw the eyes looking off to the side for a good-natured mischievous look.

The nose is small on both kittens and adults.

Adding a little width to the face softens the look.

Its muzzle is small, like the mouth.

NORWEGIAN FOREST CAT

This popular cat hails from Europe and has a thick, fluffy coat, as evidenced by the generous amount of ruffles on the sides of the face.

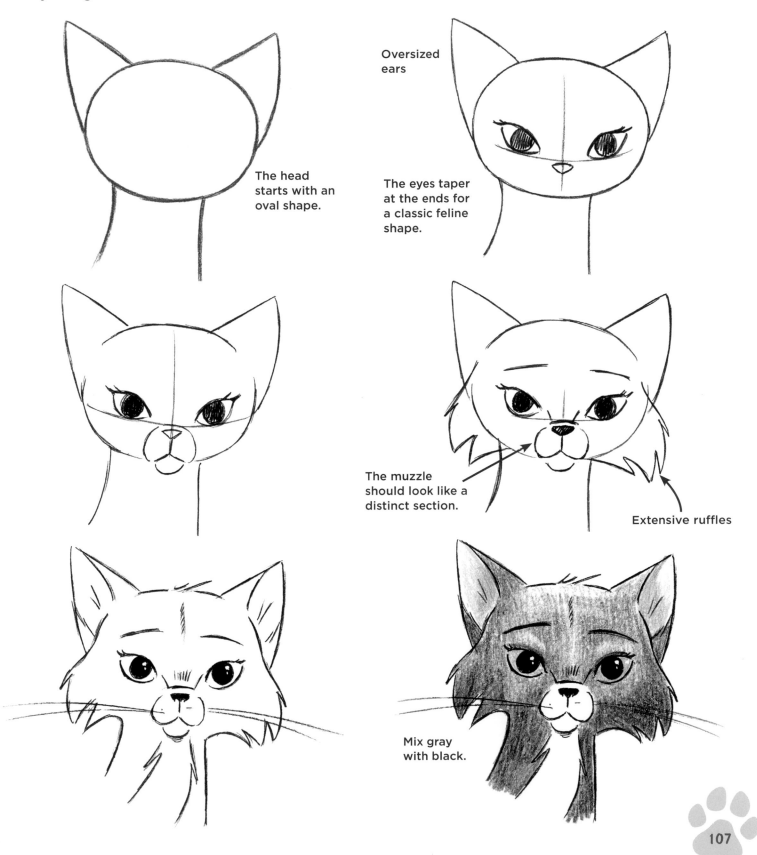

The head starts with an oval shape.

Oversized ears

The eyes taper at the ends for a classic feline shape.

The muzzle should look like a distinct section.

Extensive ruffles

Mix gray with black.

EGYPTIAN CAT

These hadsome felines have low foreheads and slightly extended noses that give them an exotic look. You can imagine this handsome fellow keeping the pyramids free of pests.

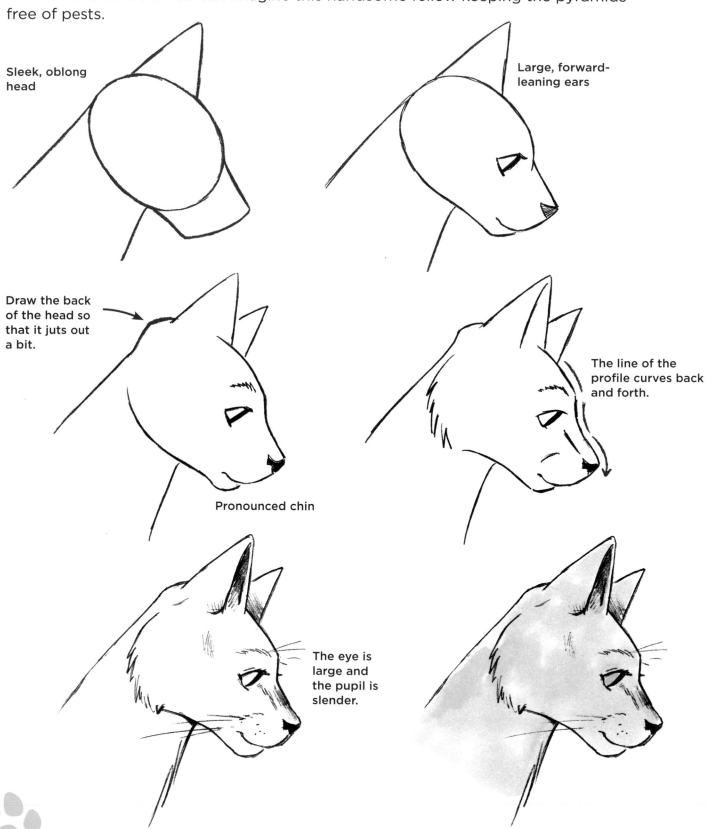

Sleek, oblong head

Large, forward-leaning ears

Draw the back of the head so that it juts out a bit.

The line of the profile curves back and forth.

Pronounced chin

The eye is large and the pupil is slender.

RUSSIAN BLUE CAT

The Russian blue has a coat that I'd describe as "controlled fluffiness." I'm not sure you'll find that term in any veterinarian's handbook, but it's pretty accurate. The Russian blue has a friendly face, as if it's saying, "Hey, what's that you're eating?"

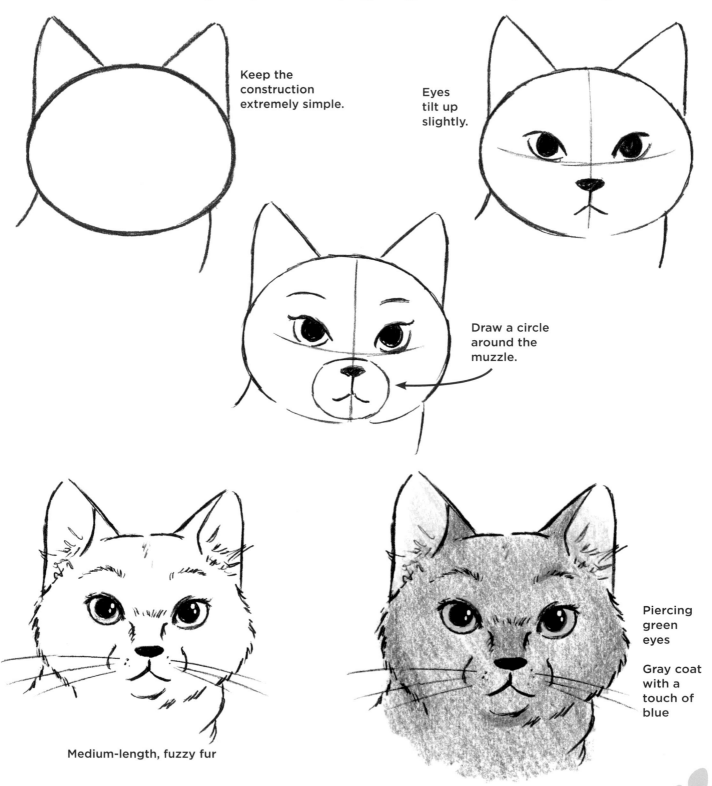

Keep the construction extremely simple.

Eyes tilt up slightly.

Draw a circle around the muzzle.

Medium-length, fuzzy fur

Piercing green eyes

Gray coat with a touch of blue

PRETTY KITTY

In this drawing, the lip pads and chin are prominent, but the nose is subtle. The upper lip pads and the chin should fit together snugly like three compartments of the same object.

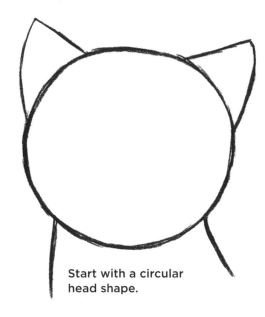

Start with a circular head shape.

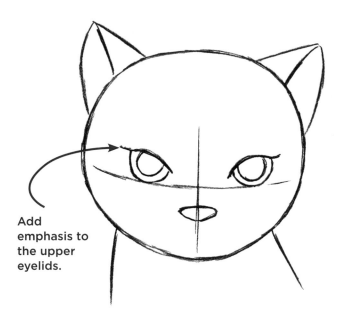

Add emphasis to the upper eyelids.

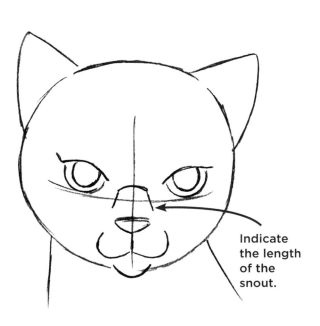

Indicate the length of the snout.

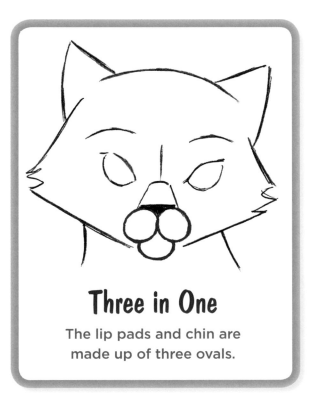

Three in One

The lip pads and chin are made up of three ovals.

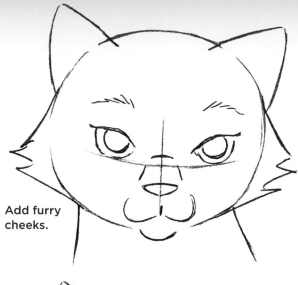

Add furry cheeks.

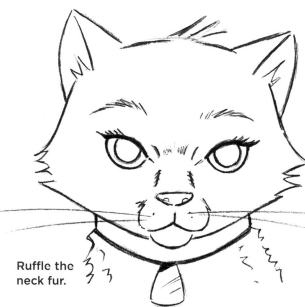

Ruffle the neck fur.

Let Your Hair Down

To create a softer look, draw the hair hanging down.

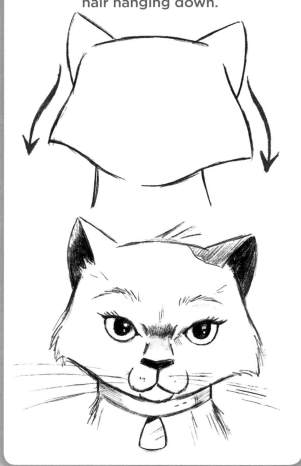

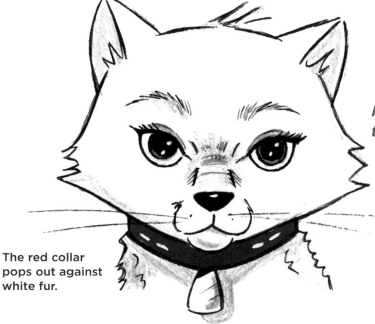

I will now permit you to pet my head.

The red collar pops out against white fur.

DRAWING THE COAT

Now we're going to draw some bodies, starting with a few tips on drawing the coat. The coat is actually part of the foundation of the drawing, so we'll develop it early on. The idea of a "full coat" can be a bit of a misnomer. Generally, the coat is only full on one side: the bottom. Let's see how it works.

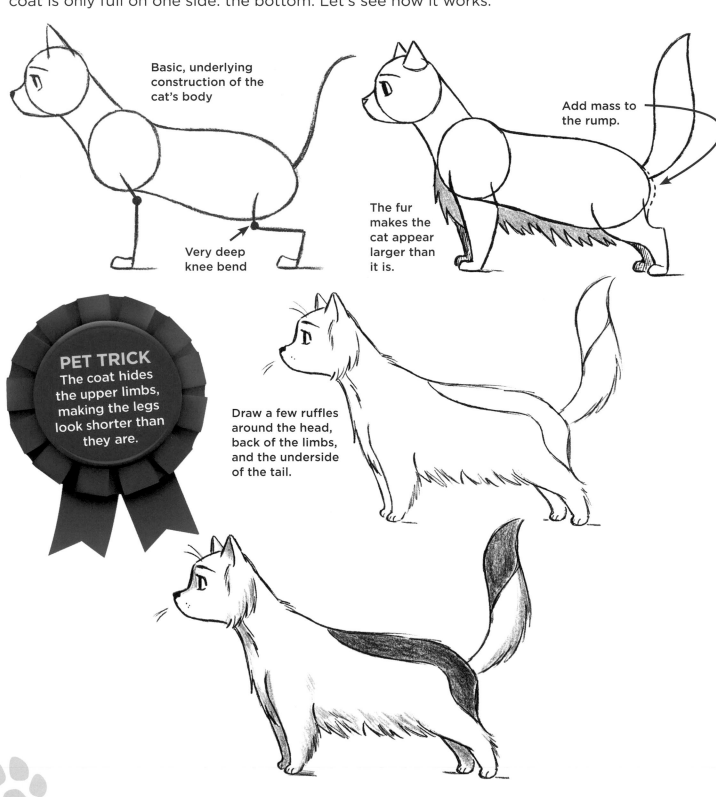

Basic, underlying construction of the cat's body

Very deep knee bend

Add mass to the rump.

The fur makes the cat appear larger than it is.

PET TRICK
The coat hides the upper limbs, making the legs look shorter than they are.

Draw a few ruffles around the head, back of the limbs, and the underside of the tail.

WALKING CAT

While dogs tend to have good posture, cats are a lot slinkier. We look to the line of the back to inform us of the winding nature of the pose.

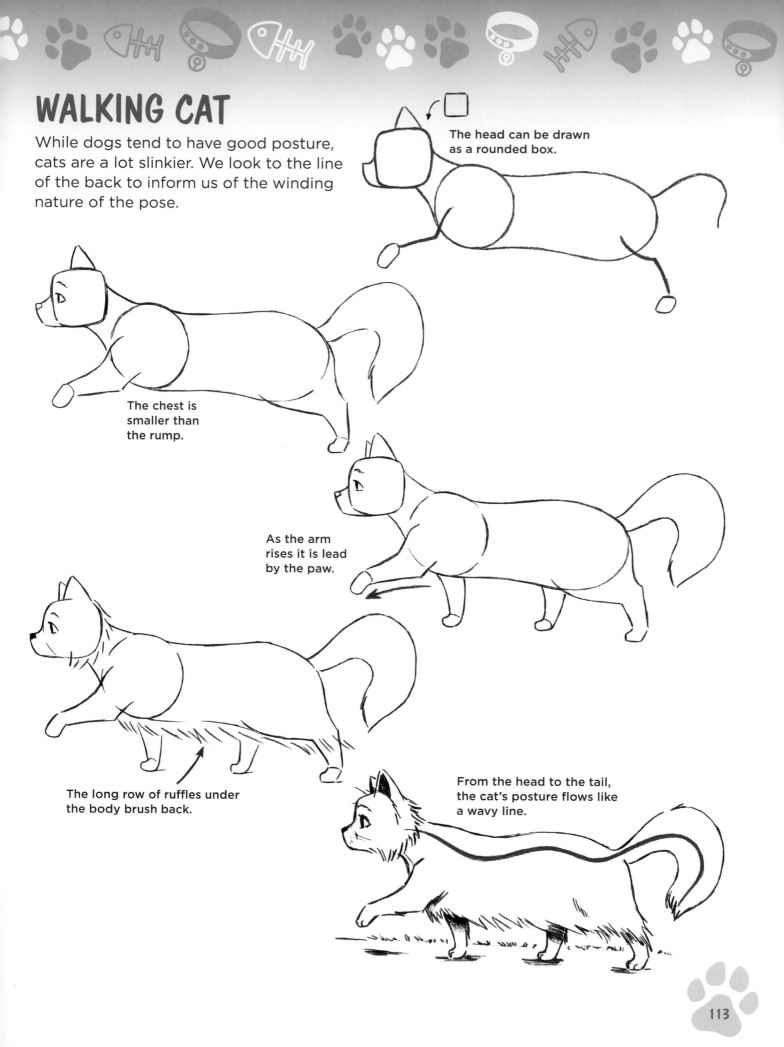

The head can be drawn as a rounded box.

The chest is smaller than the rump.

As the arm rises it is lead by the paw.

The long row of ruffles under the body brush back.

From the head to the tail, the cat's posture flows like a wavy line.

AMERICAN BOBTAIL

The American bobtail is a rare breed that is gregarious and amusing. Its attentive expression makes it look as though it's always up for joining the fun. Its signature short tail curls at the end.

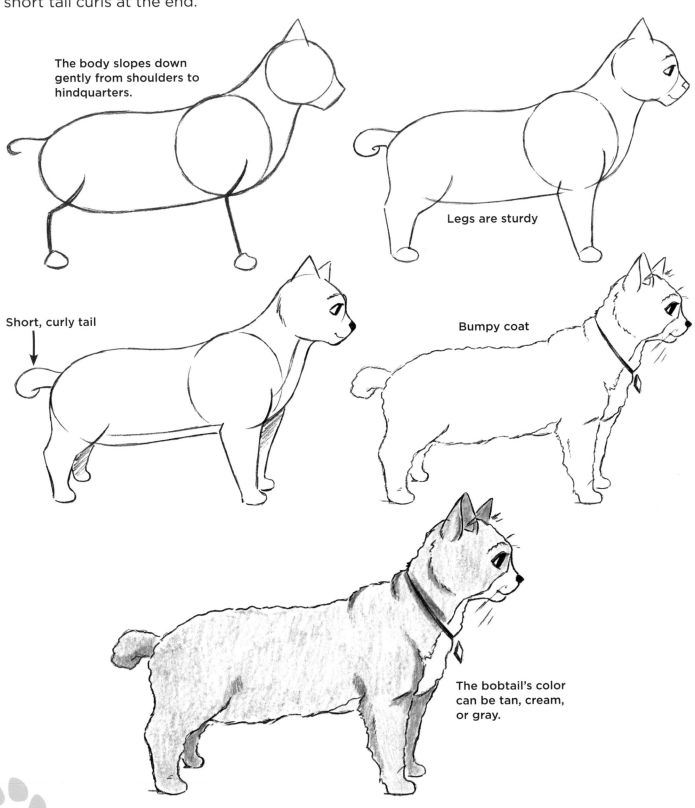

The body slopes down gently from shoulders to hindquarters.

Legs are sturdy

Short, curly tail

Bumpy coat

The bobtail's color can be tan, cream, or gray.

LET'S PLAY!

To create this natural-looking pose, draw the chest as a large circle and keep it prominent through each of the steps. The hindquarters are somewhat smaller in comparison.

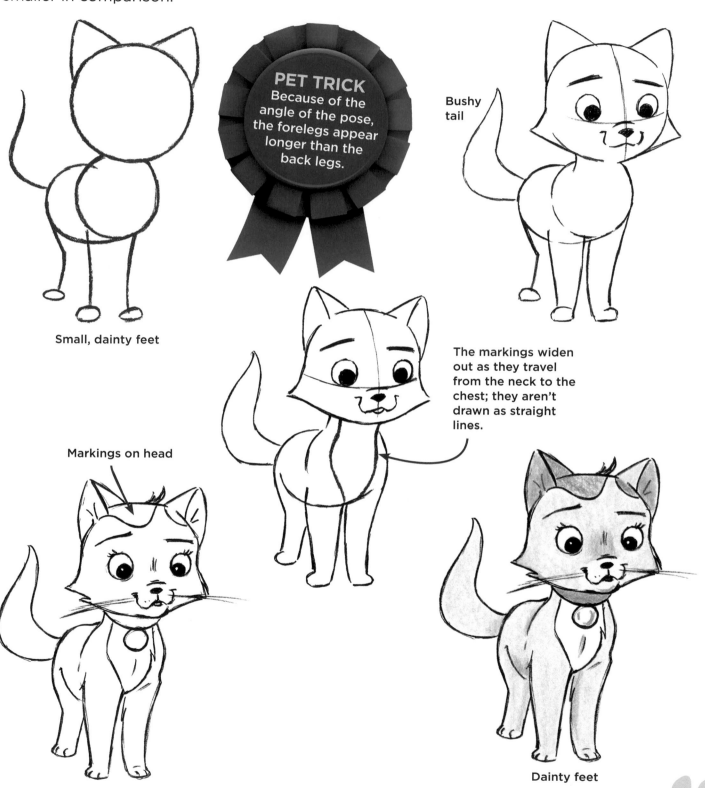

PET TRICK
Because of the angle of the pose, the forelegs appear longer than the back legs.

Bushy tail

Small, dainty feet

The markings widen out as they travel from the neck to the chest; they aren't drawn as straight lines.

Markings on head

Dainty feet

115

CLASSIC SITTING POSE

Cats are often quiet observers, and therefore their sitting posture is reserved and somewhat drawn in. However, the head remains straight up and watchful. The upper body (chest) retains its oval shape, while the lower back arches significantly.

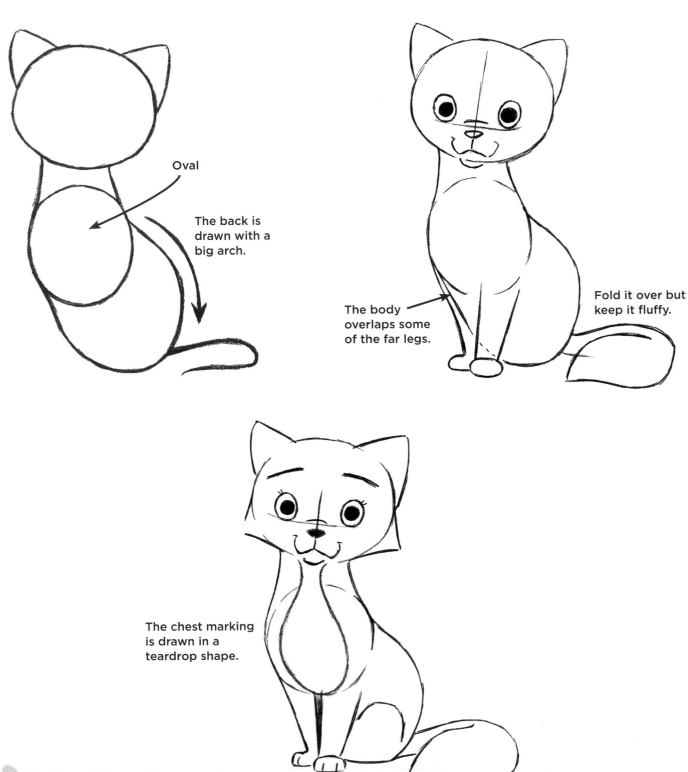

Oval

The back is drawn with a big arch.

The body overlaps some of the far legs.

Fold it over but keep it fluffy.

The chest marking is drawn in a teardrop shape.

Furry Face

Instead of a clean line, you can break up the outline of the face with short, rough strokes.

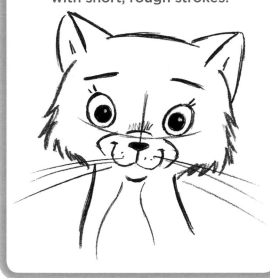

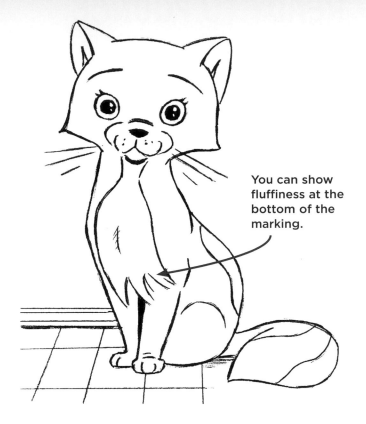

You can show fluffiness at the bottom of the marking.

I'm just about done training my human.

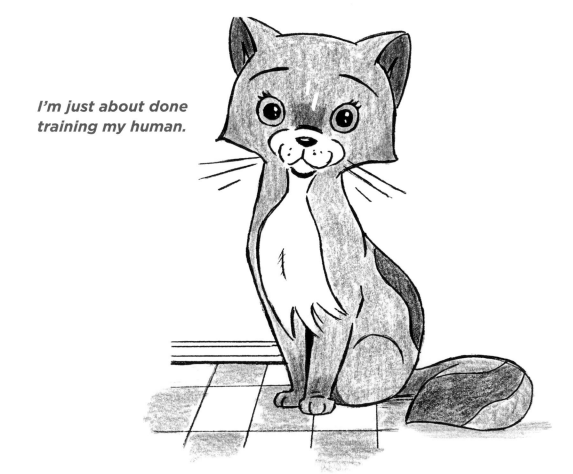

READY TO POUNCE

This classic pose is drawn with the elbows tucked under the shoulders. The paws are extended just to the chin. The back paws are hidden by the bundled-up thighs.

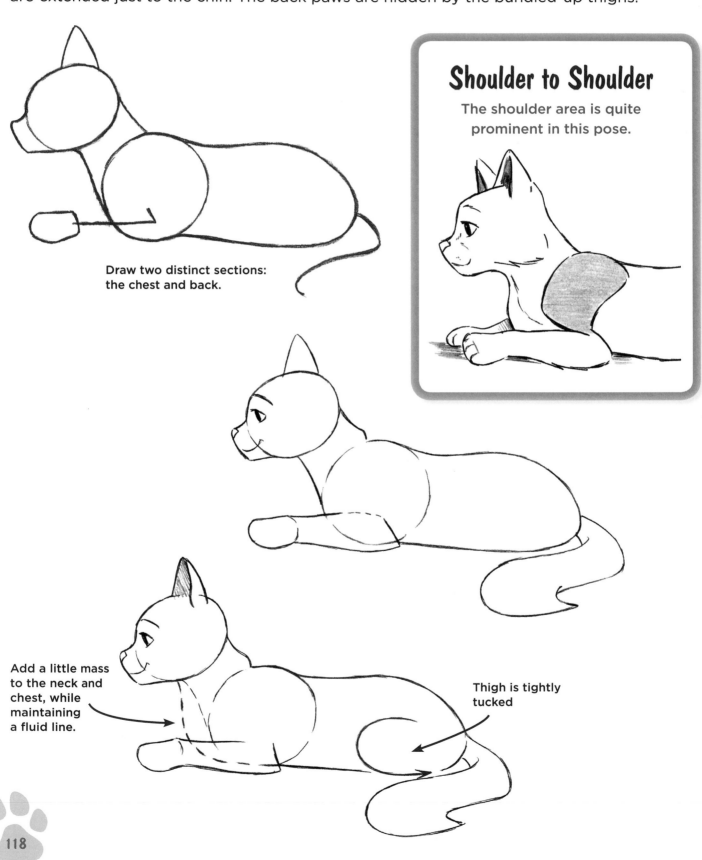

Draw two distinct sections: the chest and back.

Shoulder to Shoulder

The shoulder area is quite prominent in this pose.

Add a little mass to the neck and chest, while maintaining a fluid line.

Thigh is tightly tucked

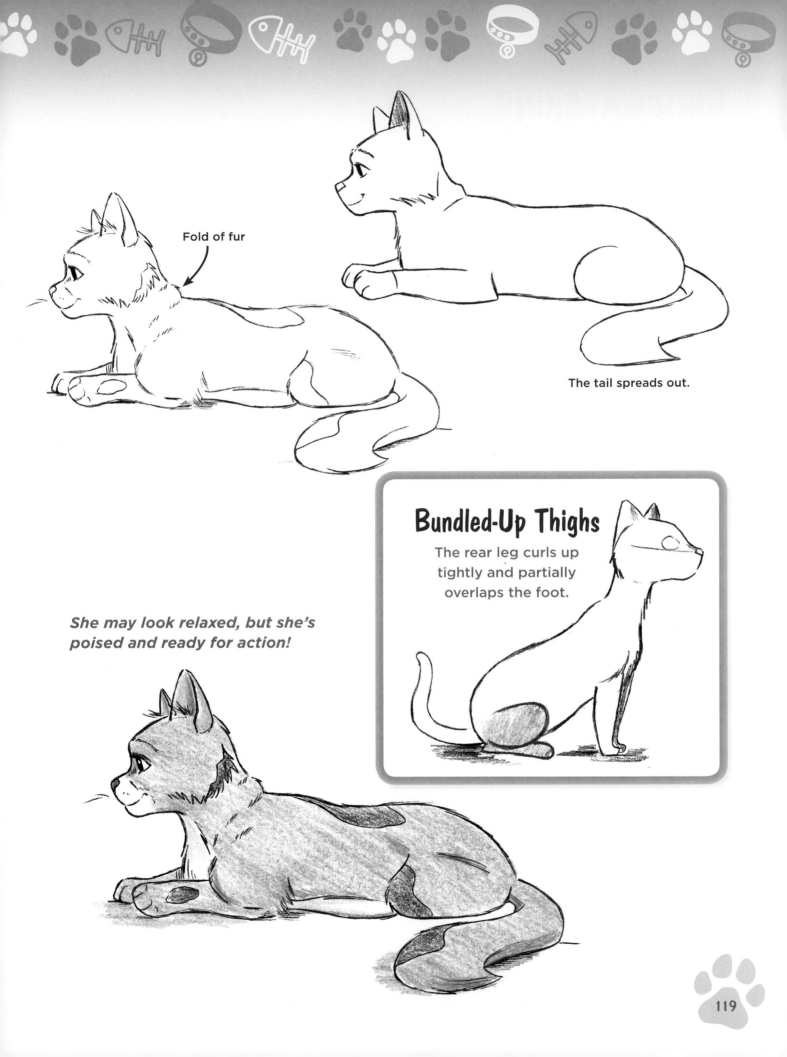

Fold of fur

The tail spreads out.

Bundled-Up Thighs

The rear leg curls up tightly and partially overlaps the foot.

She may look relaxed, but she's poised and ready for action!

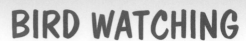

BIRD WATCHING

To get the most out of a back pose, draw the body in three distinct sections: the head, the upper body, and the rump. The head and rump are the widest sections.

Long

Wide

Add ruffles on side of the face.

PET TRICK
Indicate the spine to make a sitting pose look convincing.

The hind legs are added on as simple shapes.

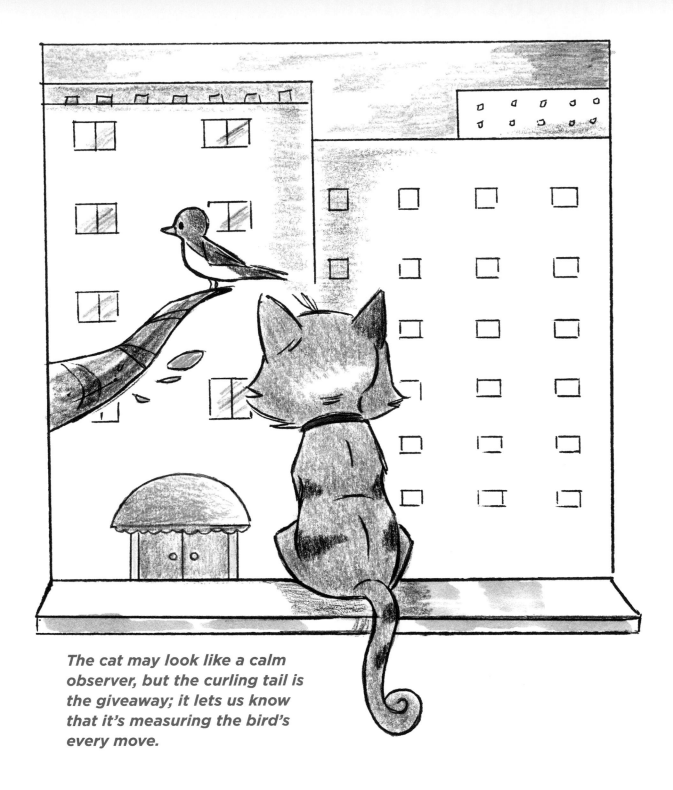

The cat may look like a calm observer, but the curling tail is the giveaway; it lets us know that it's measuring the bird's every move.

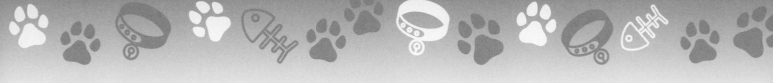

THE FAMOUS "CAT BUMP"

If you have a cat, you can expect it to affectionately bump and wind around your leg—just as you're carrying something breakable into the house. Of course, they're not actually timing it to mess with you. That would be downright diabolical.

Body leans forward and head turns up

Head overlaps the leg

The chest marking begins at the ends of the smile and winds around to the chest.

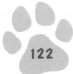

122

PET TRICK
To show affection, have the cat lead with the side of her face.

Head tilts on a diagonal

The whiskers are also drawn on an angle.

RELAXATION

With the arms stretched out in this classic pose, the body is almost perfectly horizontal. The forearms are positioned horizontally, too. But the head remains alert—always!

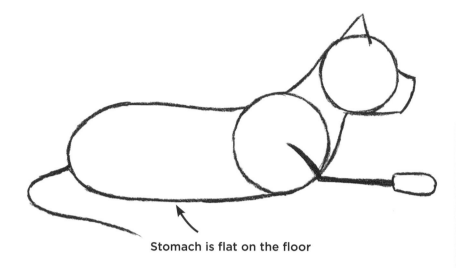

Stomach is flat on the floor

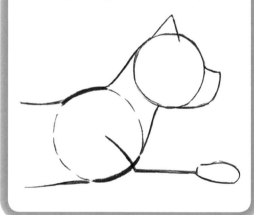

Catty-Corner

The shoulder crest and the chest are positioned diagonally to each other.

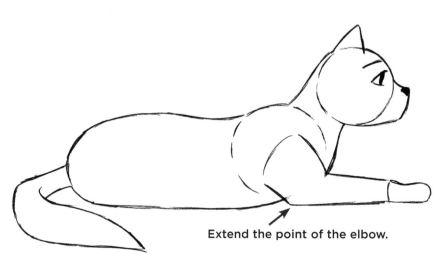

Extend the point of the elbow.

The line of the thigh starts above the tail, creating a pleasing curve.

Shadow Play

By resting on its elbow, the cat creates a small shadow below its chest.

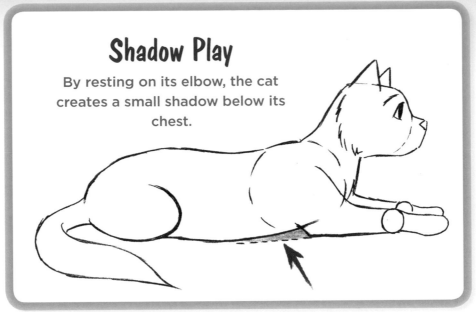

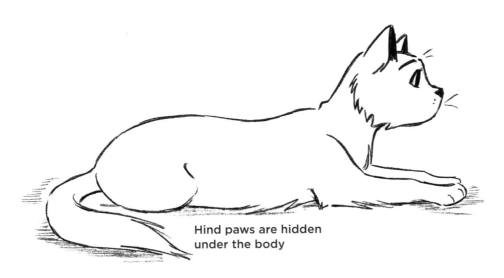

Hind paws are hidden under the body

Note that the back slopes between the shoulders and rump.

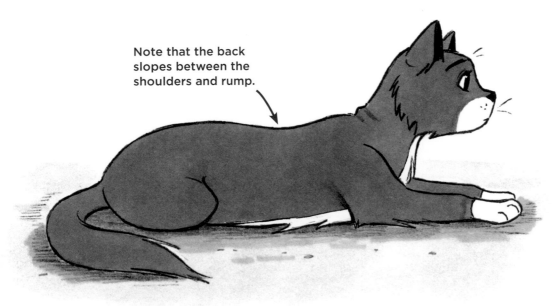

CAT NAP

Cats are experts at falling asleep in "improbable" poses. Improbable poses are poses that, while physically possible, are unusual and often funny. Some of them remind us of goofy human behaviors.

Arms and legs hang down

Closed eyes

Paw turns back

Add a little fold of skin at the base of the neck.

Leave the mouth open for snoring.

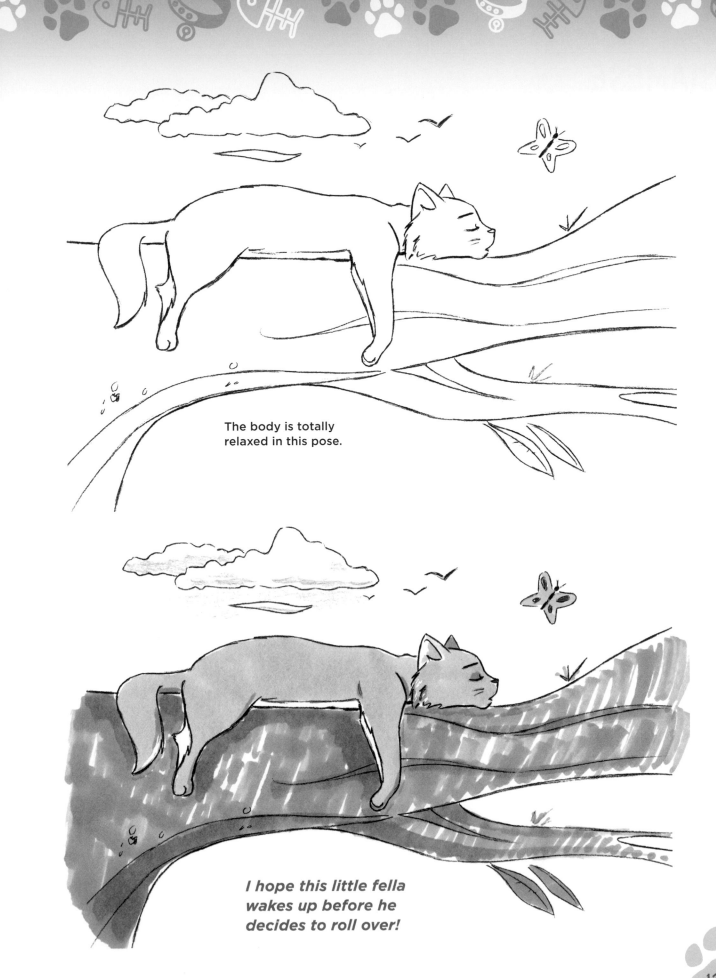

The body is totally relaxed in this pose.

I hope this little fella wakes up before he decides to roll over!

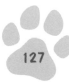

SIAMESE

The seal point Siamese cat has a narrow, rather than a wide, face. Its clever and sophisticated demeanor has made it one of the breed's more popular types.

Paw Detail

The "fingers" of the paws are different lengths. a Guideline keeps them consistent.

Long and winding tail

The head is not quite as narrow as the Egyption breed, but similar.

Draw a small mouth.

Tiny little feet

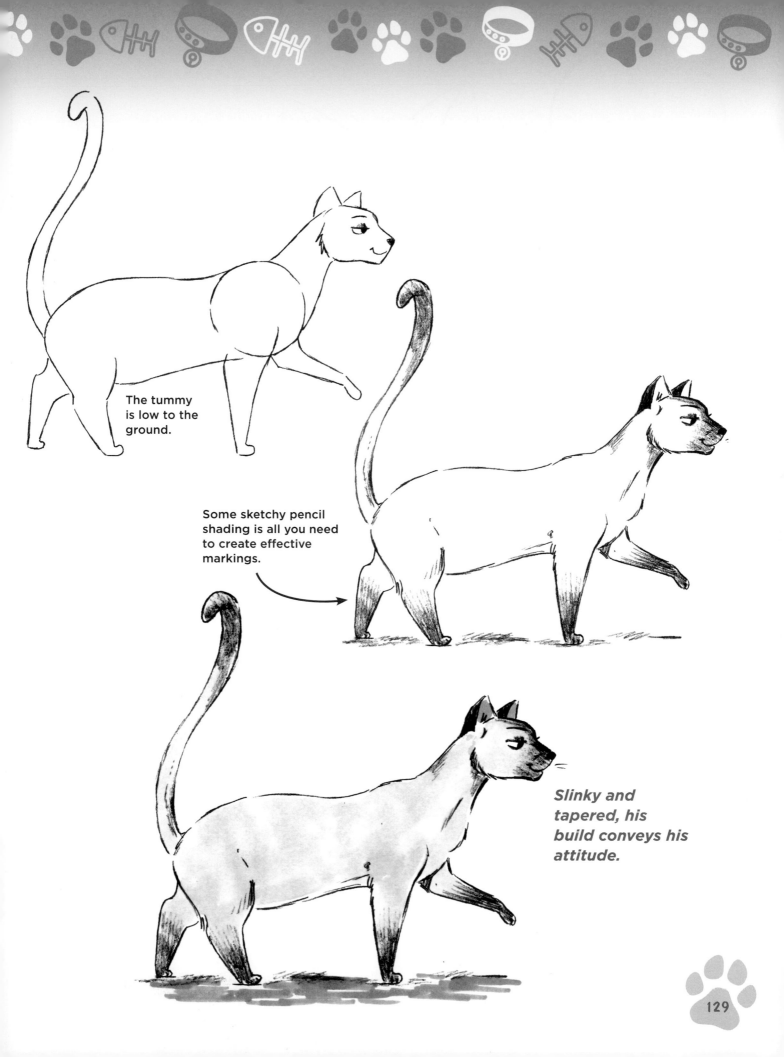

The tummy is low to the ground.

Some sketchy pencil shading is all you need to create effective markings.

Slinky and tapered, his build conveys his attitude.

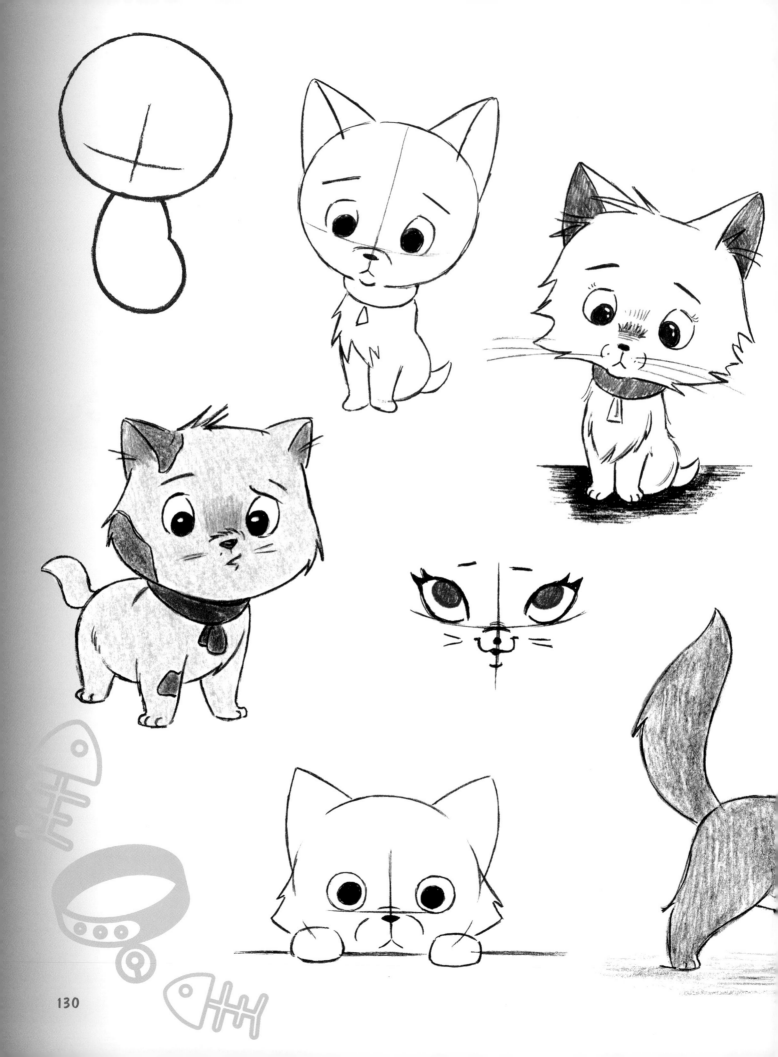

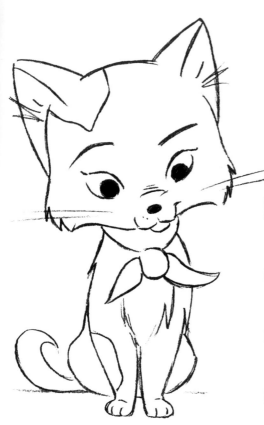

DRAWING CATS

KITTENS, KITTENS, KITTENS!

We've drawn a few kittens in the preceding chapter, but just in case you can't get enough of them—and who can?—let's add to this fluffy festival. We'll draw a variety of engaging kittens, focusing on the basic shapes and proportions, with a variety of poses, fur details, and expressions.

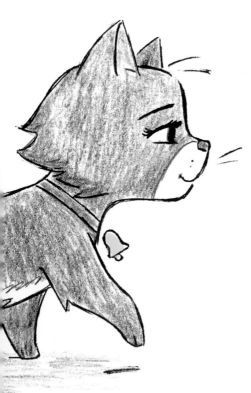

SURPRISED KITTEN

Here's a character design trick I'd like to share with you. It works as well on dogs as it does on cats. If you want to draw a lovable kitten or puppy, draw it with its head popping up from behind something with a perplexed expression. Try it and see what you come up with.

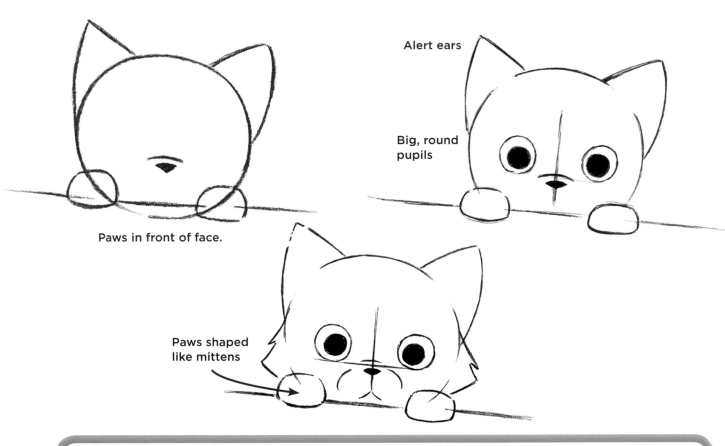

Paws in front of face.

Alert ears

Big, round pupils

Paws shaped like mittens

Make it Personal

It's easy to personalize your drawings by changing the coloring, markings, expression, and details. Just use these steps as a basic guide.

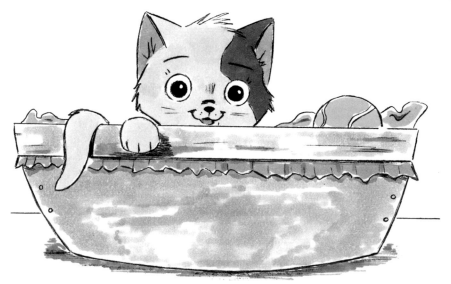

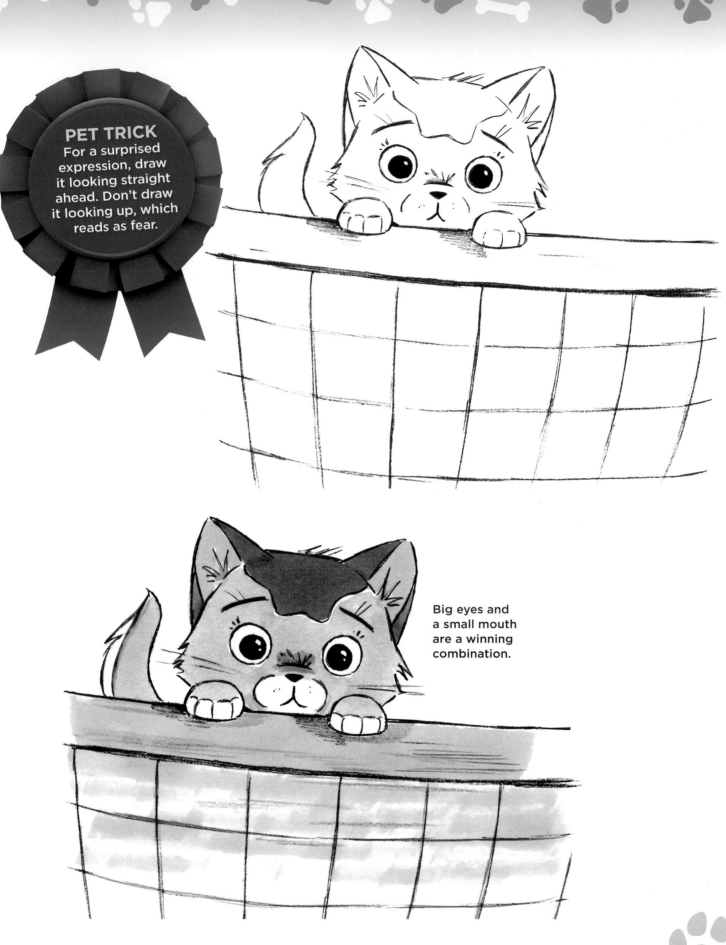

Big eyes and a small mouth are a winning combination.

OUT FOR A STROLL

Let's simplify the position of the kitten's legs in a walk. The rear leg makes contact with the ground as it pushes back. At the same time, the front leg lifts off the ground and moves forward. That's the basic template we'll use.

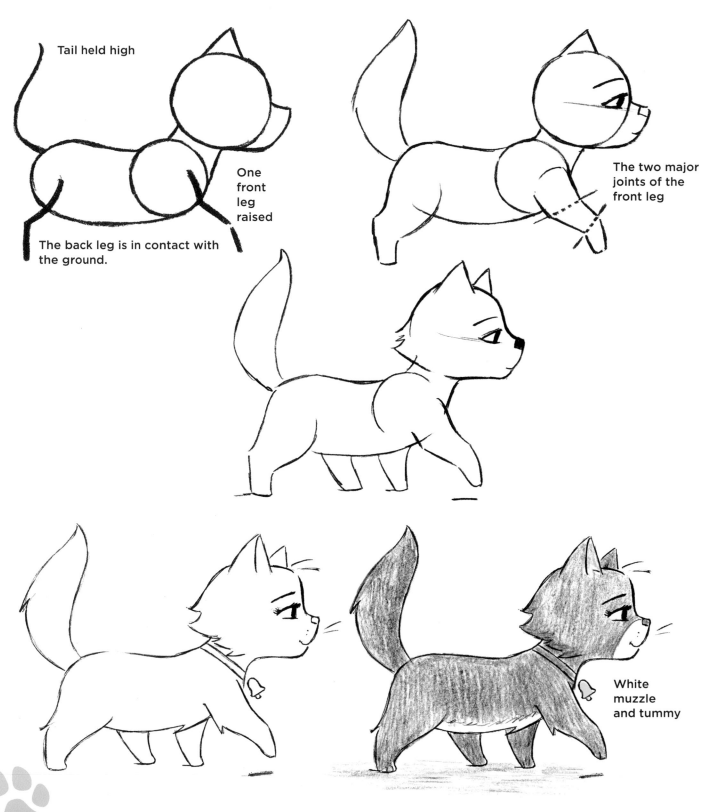

Tail held high

One front leg raised

The back leg is in contact with the ground.

The two major joints of the front leg

White muzzle and tummy

A WALK WITH BOUNCE IN IT

Want to know how to add a little bounce to a walk? It's simple: Just draw one of the forearms raised high off the ground. It's the raising of the limb, rather than the expression, that is the strongest indication of a happy walk.

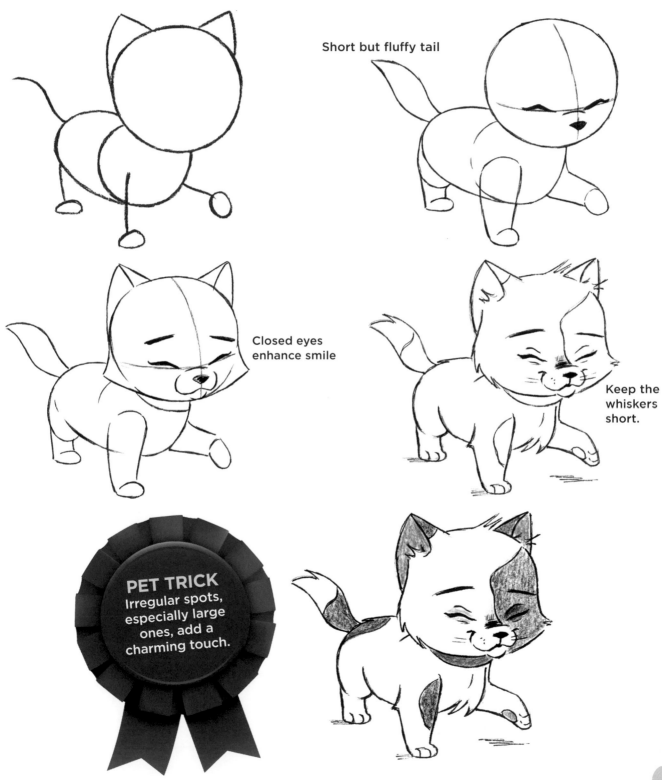

Short but fluffy tail

Closed eyes enhance smile

Keep the whiskers short.

PET TRICK
Irregular spots, especially large ones, add a charming touch.

CALICO KITTEN

Big, bold markings and spots are ideal for kittens. These youngsters don't require a delicate touch. In fact, overwhelming them with big, bold spots or patterns creates a sweet and awkwardly engaging look.

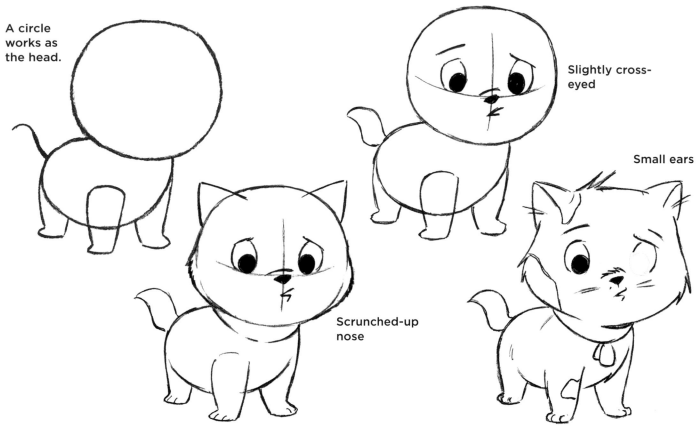

A circle works as the head.

Slightly cross-eyed

Small ears

Scrunched-up nose

Spots: Two Ways

Spots can either be high contrast, like the black and white version, or low contrast, such as the tan, black, and orange one. Both are effective ways to create markings.

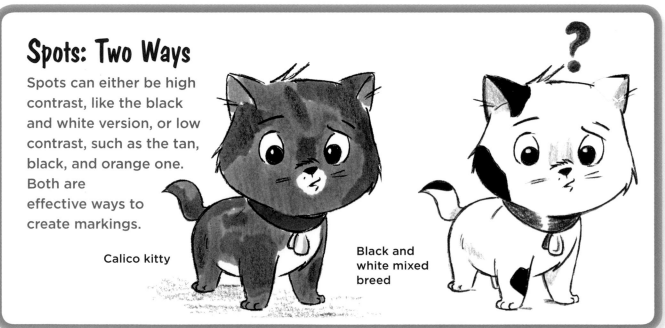

Calico kitty

Black and white mixed breed

SUPER FLUFFY

Some kittens are meekly built, but they have a sea of hair to make up for it. The fluffiest part is typically around the head, which makes it look disproportionately large. It's also an appealing look, because it requires instant hugging..

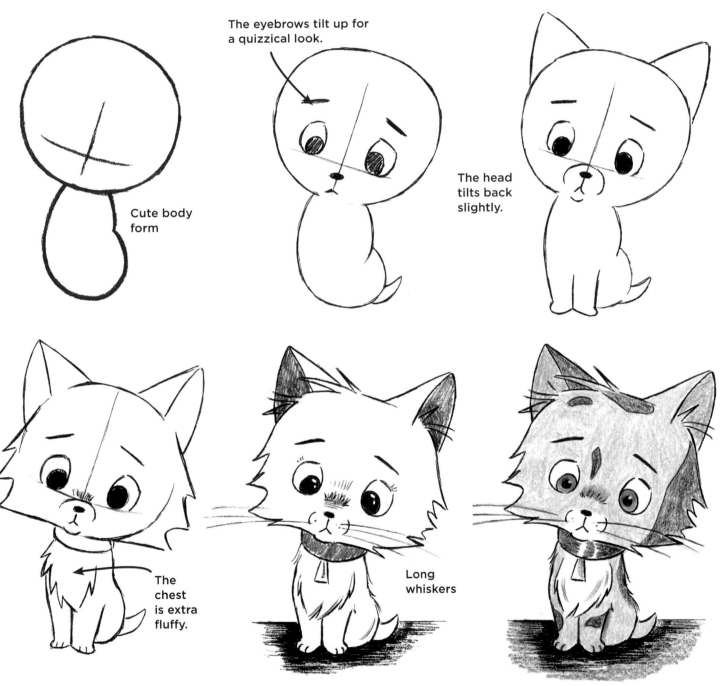

Cute body form

The eyebrows tilt up for a quizzical look.

The head tilts back slightly.

The chest is extra fluffy.

Long whiskers

The kitten's hair remains somewhat chaotic. It contributes to that dear expression of puzzlement.

ACCESSORIES

Whether it's a fancy collar, a cat sweater, a bowtie, or a scarf, a pet accessory is an appealing addition to a drawing. It makes the pet look cared for. By drawing a thick scarf around the neck of this kitten, you make it appear cozy and comfortable.

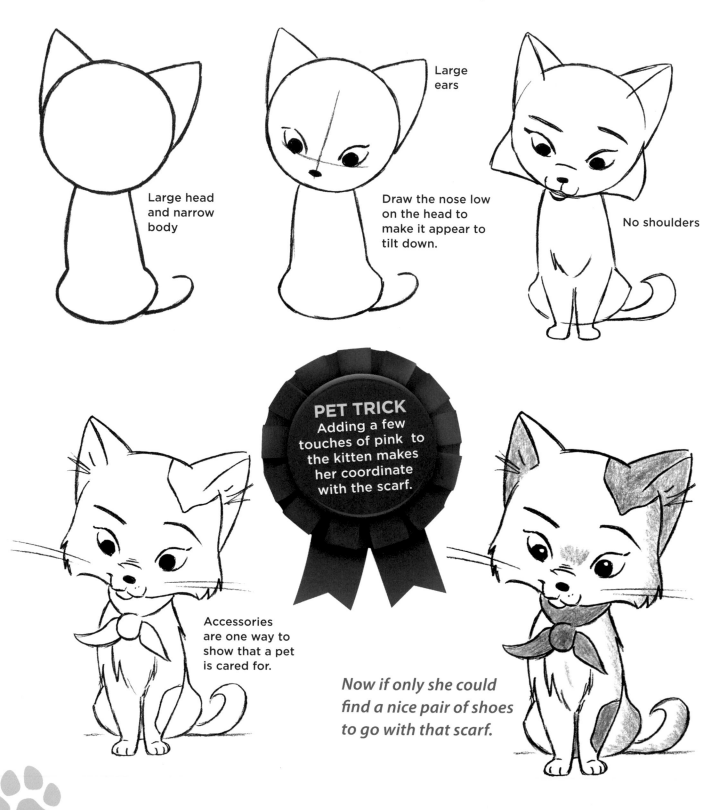

Large head and narrow body

Large ears

Draw the nose low on the head to make it appear to tilt down.

No shoulders

PET TRICK
Adding a few touches of pink to the kitten makes her coordinate with the scarf.

Accessories are one way to show that a pet is cared for.

Now if only she could find a nice pair of shoes to go with that scarf.

A MOST CURIOUS BALLOON

Cats, but especially kittens, can find the most ordinary objects immensely interesting. I once had a kitten that found my ears to be an endless source of fun. It was adorable, but annoying.

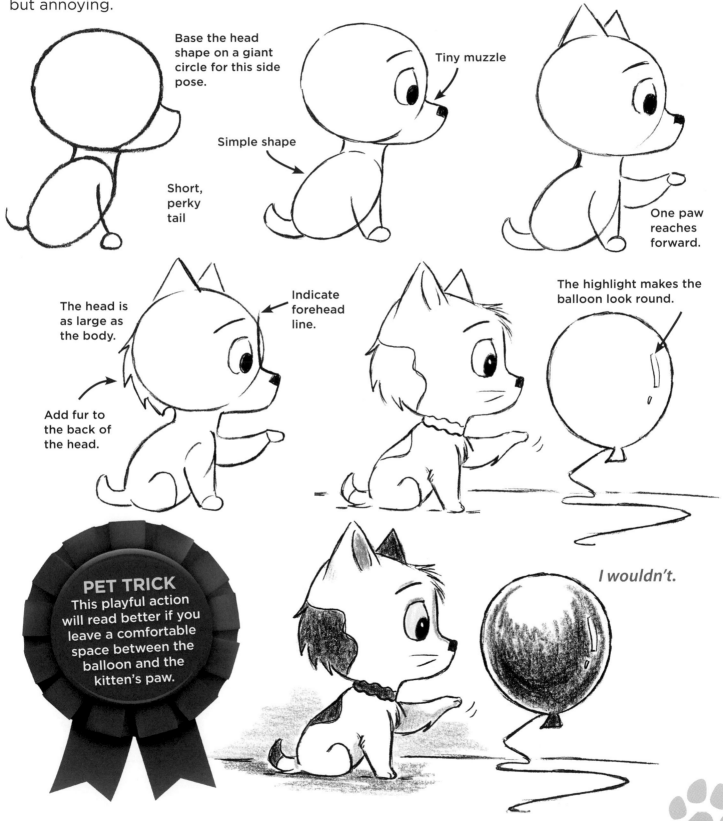

Base the head shape on a giant circle for this side pose.

Short, perky tail

Tiny muzzle

Simple shape

One paw reaches forward.

The head is as large as the body.

Indicate forehead line.

Add fur to the back of the head.

The highlight makes the balloon look round.

PET TRICK
This playful action will read better if you leave a comfortable space between the balloon and the kitten's paw.

I wouldn't.

STARGAZING

I've saved this drawing for last to impart an important idea to you: don't be afraid to simplify your drawings. Many beginning artists believe they must master all the details. That's certainly a good goal. But often, you can get as much feeling from a simplified drawing as from a complex one.

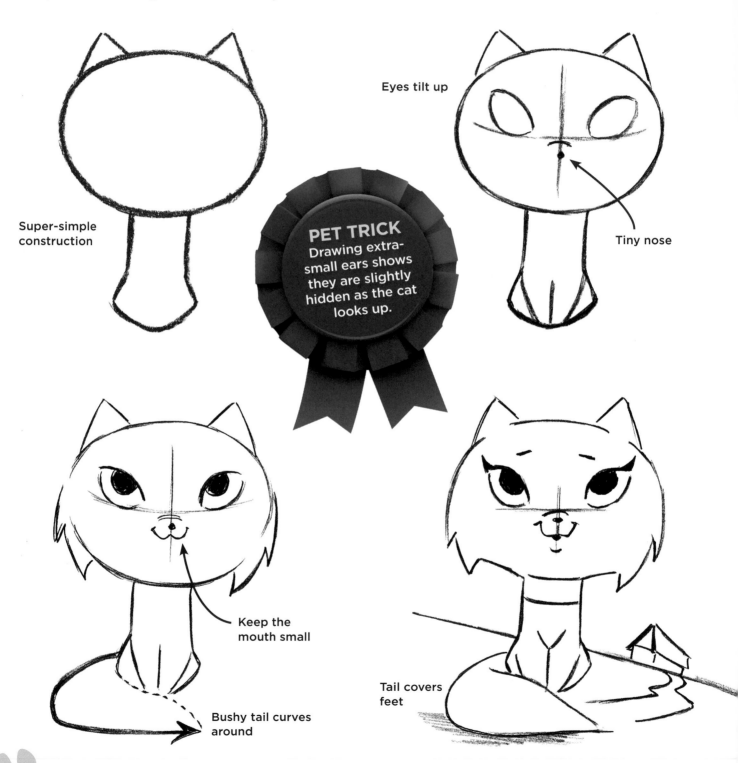

Super-simple construction

Eyes tilt up

Tiny nose

PET TRICK
Drawing extra-small ears shows they are slightly hidden as the cat looks up.

Keep the mouth small

Bushy tail curves around

Tail covers feet

Look Up!

The most effective way to portray eyes looking skyward is to leave as much space as possible under the pupils.

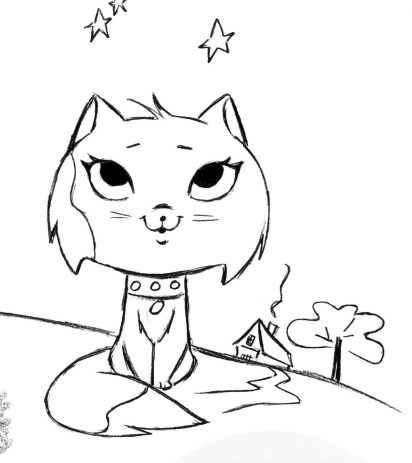

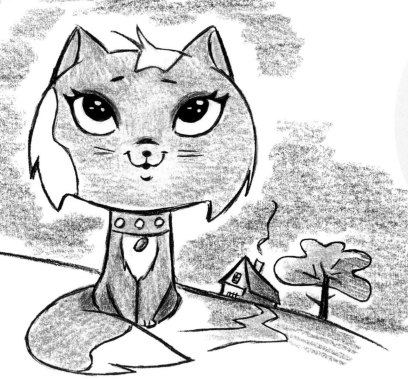

Thanks for allowing me to participate in your creativity as an artist. On behalf of myself and all the pets in this book, we wish you the very best in your creative journey.

—Christopher Hart

INDEX

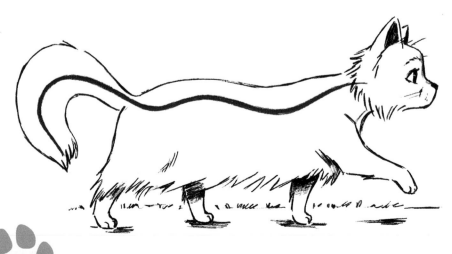

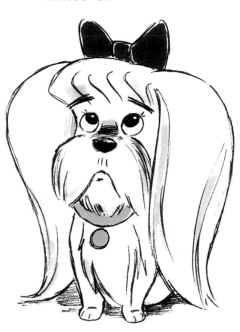
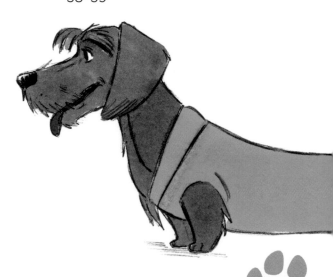

Christopher Hart is the world's best-selling author of how-to-draw books, with more than 7 million copies sold. His books also have a huge international audience, having been translated into more than 20 languages. In his more than 50 titles, he offers artists accessible, generously illustrated, and clearly written step-by-step instruction on a wide variety of how-to-draw subjects, including manga, figure drawing, cartooning, comics, and animals. Learn more at **christopherhartbooks.com.**